Francisco de Goya

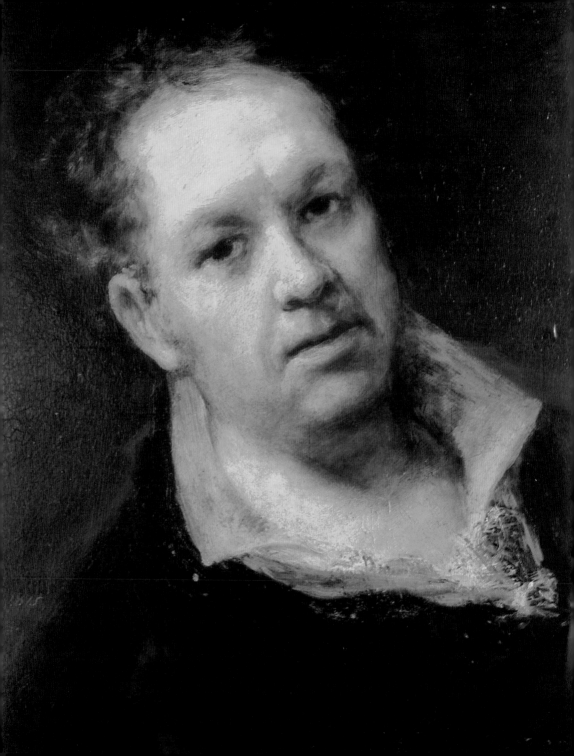

Elke Linda Buchholz

Francisco de Goya

Life and Work

KÖNEMANN

Early Years
Page 6

Move to Madrid
Page 16

Artist to Nobility
Page 24

1746	1770	1780
1805	1810	1814

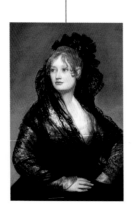

The Height of Fame
Page 54

Times of War
Page 64

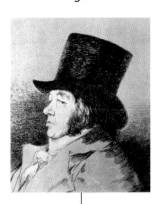

Early Years 1746–1773

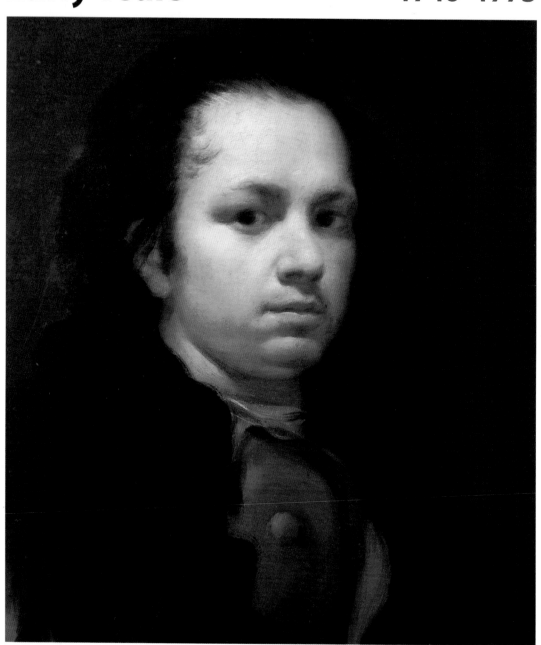

When, at 13, Goya began to learn the craft of painting, no one could have foreseen that he would one day become one of the greatest painters of Spanish – and European – art. Even when he traveled to Italy in his mid-twenties and later earned a modest living as a church painter in Saragossa, there was no hint of the extraordinary career that awaited him. Little is known about Goya's youth or the roots of his work as an artist. If his later comments are to be believed, in his youth he was a tough good-for-nothing who was not afraid to test his courage in the bullring. He pursued his career as a painter proudly and self-confidently, even though the Royal Academy in Madrid refused to acknowledge his work. He made a name for himself in the provinces, made contacts among influential people, and disciplined himself to complete his commissions – some of them large ones – to the satisfaction of his patrons. He also painted portraits and made a number of etchings.

Opposite:
Self-Portrait
1771–1775
Oil on canvas
58 x 44 cm
Madrid, Marquesa de Zurgena

Right:
Flight into Egypt
1771–1772
Etching
13 x 9.5 cm
Private collection

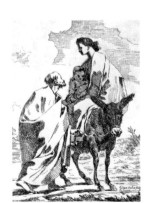

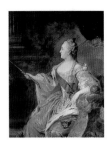

Czarina Catherine II, 1763

Goya ca. 1773 (presumed self portrait),

1749 Birth of Johann Wolfgang von Goethe.

1750 Death of Johann Sebastian Bach.

1751 First volume of Diderot and d'Alembert's *Encyclopédie* published.

1756–1763 The Seven Years War between Prussia and Austria.

1759 Charles III becomes King of Spain.

1762 Catherine II (the Great) ascends the Russian throne.

1764 The Spinning Jenny is invented in England.

1766 Popular uprising in Madrid (the Esquilache Uprising).

1771 The first *Encyclopaedia Britannica* is published.

1773 Dissolution of the Jesuits by Pope Clement XIV.

1746 Francisco de Goya y Lucientes born on 30 March at Fuendetodos, near Saragossa.

1760 Goya's apprenticeship with the painter José Luzán in Saragossa begins.

1763 Travels to Madrid; unsuccessful in the Academy competition.

1770 Travels to Italy.

1771 Achieves an "honorable mention" in the competition at the Parma Academy, then returns to Spain. First important commission for a fresco in the Church of Nuestra Señora del Pilar in Saragossa.

1773 Marriage to Josefa Bayeu.

1774 Fresco in the chapel of the Aula Dei Monastery.

Youth and Apprenticeship

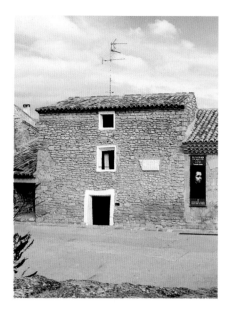

On March 30, 1746, Francisco José de Goya y Lucientes came into the world in the village of Fuendetodos, in the province of Aragon. This was the native province of his mother's family: Gracia Lucientes came from the lower ranks of the landed gentry. During the 18th century, one Spaniard in seven belonged to the broad layer of the populace classed as "aristocracy." These were the *hidalgos*, a word derived from the expression *hijo de algo*, which translates literally as "somebody's son." Among the aristocratic attitudes inherited by the hidalgos were their pride, their keen sense of honor, and disdain for any form of physical work, though they were frequently completely without means. Goya's family, too, appears to have lived in fairly impoverished circumstances. When his father, José Goya, died, he left no will, apparently because he had nothing of value to bequeath.

The family lived in Fuendetodos only briefly, soon moving back to the provincial capital, Saragossa, where Goya's father had been a member of the highly respected Goldsmith's Guild. Here, Goya attended the classes of the pious Pater Joaquin at the Escuelas Pías, a church institution. He befriended a classmate, Martin Zapater, who was to remain his closest friend throughout his life. At 13 he began his apprenticeship to the painter José Luzán (1710–1785). Luzán, a church painter who

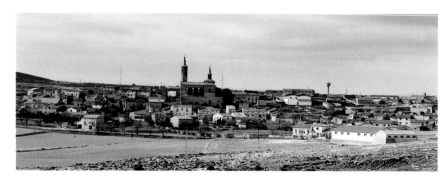

Reliquary in the church at Fuendetodos
ca. 1762
Photograph

Goya's first well-known work was a hinged reliquary for the parish church of his native village. The exterior showed a vision of the Mother of God as the Madonna of the Pillar, the interior a Madonna and St Francis of Paolo. It was destroyed in a fire in 1936.

was much in demand, had traveled to Italy in his youth and, while in Naples, had adopted the contemporary style of the Italian Late Baroque. He handed on this traditional concept of art to his pupils by having them patiently copy engravings of the works of great masters. Naturally they also learned the craft of painting, grinding colors, and preparing canvases, but there was no question of developing individual artistic expression. The aim was to copy acknowledged models faithfully. During his four-year apprenticeship with Luzán, Goya also got to know his contemporary and competitor, Ramón Bayeu, and the latter's brother, Francisco, whom he later described as his teacher. There is, in fact, little doubt that Francisco Bayeu (1734–1795), who was soon to begin a dazzling career, was at

that time Goya's principal model. In 1762, Bayeu was called to Madrid to work with Anton Raphael Mengs, a German painter working in Spain, decorating the royal palace. A few years later, Bayeu rose to become court painter and created several extensive cycles of frescoes.

By comparison, Goya initially failed to achieve recognition from the artistic circles in Madrid. In 1763 and 1766 he traveled to the capital to take part in the three-yearly competition at the Academy, but did not receive a single vote. In 1773, however, he married the 26-year-old Josefa, the sister of the Bayeus, and this close relationship with the influential Bayeu family would prove to be highly advantageous to his career.

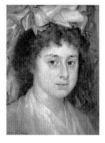

Francisco Bayeu
Portrait of Feliciana Bayeu
1787
Oil on canvas
38 x 30 cm
Madrid, Prado

In this portrait Goya's teacher, Francisco Bayeu, portrayed his own daughter Feliciana. Painted in soft tones, with light brush strokes, this sensitive portrait was long thought to be by Goya.

Early Works

Goya twice participated unsuccessfully in the competition held every three years by the Madrid Academy of Art, the first prize for which was a bursary in Rome.

A career as an artist was unthinkable without academic recognition, and a study trip to Italy was every artist's dream. Only in Italy, above all in Rome, could one study the masterpieces of antiquity, the paintings of both Raphael and Michelangelo, the art of the Italian Baroque. Goya decided to travel to Italy at his own expense. Very few paintings by him are extant from the period prior to his journey. Among these are two small paintings in which he recorded political events of the time in a rapid, sketch-like style: the Esquilache uprising in Madrid and the expulsion of the Jesuits.

During his trip to Italy, Goya stayed in Rome for approximately a year and managed to earn a living by painting. He made contact with other artists and took the opportunity to study the technique of fresco painting. In this type of painting on walls, color is applied to fresh plaster just before it dries, a technique that requires confidence and a very sure hand. The Baroque ceiling paintings in the churches of Rome are among the finest examples of this technique.

In Italy, Goya was also finally able to win a measure of academic recognition. In 1771 he entered the competition at the renowned Parma

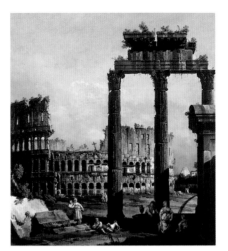

Bernardo Bellotto
Capriccio with the Coliseum
ca. 1743
Oil on canvas
95 x 89 cm
Parma, Galleria Nazionale

In the 18th and 19th centuries, the ruins of classical Rome were a great inspiration to artists, who traveled to Rome from all over Europe to study the antiquities.

Academy with a painting on the theme of *Hannibal Contemplating Italy for the First Time, From the Alps*, a typical academic theme for history paintings of the time. The jury praised Goya's light brush strokes and the expressive representation of the figures – but did not award him first prize.

Hannibal Contemplating Italy for the First Time, From the Alps
ca. 1771
Study in oils
46 x 40 cm
Madrid, Private collection

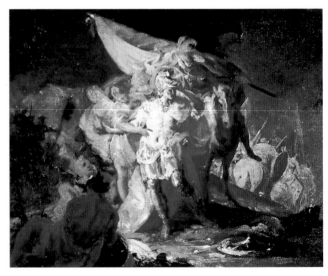

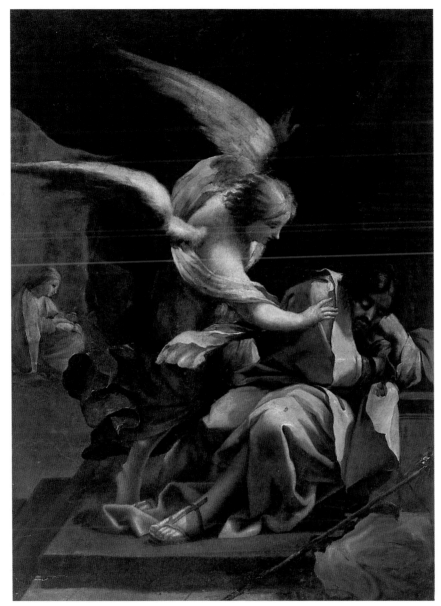

The Dream of St. Joseph
1770–1772
Oil on plaster, transferred to canvas
130 x 95 cm
Saragossa, Museo de Bellas Artes

It was probably soon after his journey to Rome that Goya completed his first major commission, a cycle of religious frescoes in the chapel of the Sobradiel Palace in Saragossa. In *The Dream of St. Joseph*, the angel calls on St. Joseph not to abandon his pregnant wife, the Virgin Mary. The diagonal composition of the painting was adopted by Goya from an engraving of a painting by the French painter Simon Vouet. Goya had learnt this common practice of copying existing works during his apprenticeship, from his teacher Luzán. The paintings were later removed from the wall and transferred to canvas.

Towards the end of 1771 he returned to Spain. After a period of time spent in Italy, the then 25-year-old painter would be able to count on a number of important commissions, at least among influental patrons in the provinces.

Rococo and Classicism in Spain

Beauty is a most difficult art, and till now, no artist has lived who could lay claim to having perfect taste in all things.

Anton Raphael Mengs

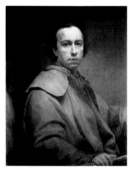

Anton Raphael Mengs
Self-Portrait
1771–1777
Oil on canvas
73 x 61 cm
Genoa, Accademia Ligustica
de Belli Arti

Anton Raphael Mengs
Portrait of Charles III
1761
Oil on canvas
154 x 110 cm
Madrid, Museo Municipal

New trends in art

When Goya began his career as a painter art was not thriving in Spain. Mediocrity and academic routine had prevailed since the Golden Age of Spanish painting, the century of Velázquez, Murillo, and El Greco. To instill fresh impetus into Spanish art, King Charles III called two of Europe's leading art figures to his court: Anton Raphael Mengs and Giovanni Battista Tiepolo. Mengs arrived from Rome on October 7, 1761; and a few months later the Venetian Tiepolo responded to the Spanish king's invitation to decorate the rooms in his new palace in Madrid. While Tiepolo, the aging Venetian master, embodied the declining age of Rococo painting, the 33-year-old Mengs was the leading representative of early Classicism. Conceptually and stylistically, the two artists could not have been more different. The highly cultivated Mengs quickly assumed a prominent role in artistic circles in Madrid, and his opinion determined the tastes of the day. He not only accepted artistic commissions, he also reformed the Academy of Art, became director of the Royal Tapestry Manufactory, and promoted young talent. He probably became aware of Goya through Bayeu, who was working under Mengs on the decoration of the royal palace in Madrid. In 1774 Mengs called Goya to the capital as a designer for the Royal Tapestry Manufactory. This was the first important step in Goya's career.

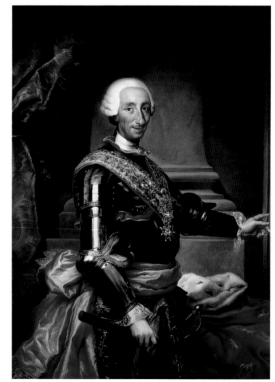

Mengs and Neoclassicism

Born in Bohemia, Mengs (1728–1779) began his brilliant career in Italy. Celebrated as one of the finest artists of his period, he spent the greater part of his life in Rome. Here he got to know Johann Joachim Winckelmann, the German art historian who had revived an interest in classical Greece, and worked to achieve a renewal in painting modeled on both antiquity and the Italian Renaissance. In addition to classical sculpture and frescoes, many artists based their work on 16th-century Italian painting, particularly the works of Raphael and Titian. With their even brush strokes and clear, balanced composition, Meng's detached, well-planned paintings were a conscious rejection of the highly decorative and often overblown art of the Baroque. He also developed a reputation as a portrait painter, his smooth, elegant likenesses satisfying the tastes and aspirations of the courtiers who commissioned them. His *Portrait of Charles III* (opposite), which shows the king in the classical pose of the sovereign, in armor enlivened by a red sash, was copied several times as the definitive portrait of the king. Even Goya used the same bearing and profile when he was later commissioned to paint the king in hunting dress. In 1777, his health failing, Mengs returned to Italy.

Tiepolo and the Rococo

Compared with the dynamic and versatile Mengs, Giovanni Battista Tiepolo (1696–1770) was not able to make his mark at the Spanish court. He did indeed decorate the most important rooms in the Madrid royal palace with his ceiling paintings, but apart from this major commission his art had little appeal in Spain. Tiepolo had won his fame as a leading international Rococo fresco painter through his painting schemes in the palaces and churches of Venice and in the Residenz (bishop's palace) in Würzburg. With his son Giovanni Domenico, he created his last great masterpiece in Madrid's Palacio Real. The large-scale ceiling paintings in the throne room and the audience room, allegories exalting the Spanish monarch, carry the observer into a completely ethereal world (right).
His frescoes provide a glimpse of the infinity of the heavens, a world flooded with clear light and filled with groups of figures floating on white clouds. The alternating areas of light and shade enhance the effect of depth in the painting, and bright, luminous colors lend a radiant, festive atmosphere to his vast, masterly designs.

Goya and the art of his time

Mengs and Tiepolo encompass the range of artistic expression prevalent in the late 18th century. Goya undoubtedly studied both with interest, though there is hardly any direct evidence of Neoclassical or Rococo influence in his work: he distanced himself from the prevalent stylistic trends at an early stage in his career. His later works, with their energetic, free-flowing brushwork, have a specifically anti-classical effect. Towards the end of his life, he created a cycle of somber frescoes that contrast profoundly with Tiepolo's luminous visions.

Above and below:
Giovanni Battista Tiepolo
Apotheosis of Spain
(details)
1762–1764
Fresco
Madrid, Palacio Real

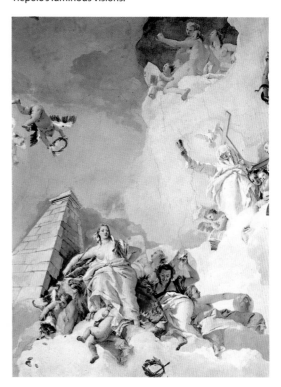

Church Painter in Saragossa

In the autumn of 1771, immediately on his return from his travels in Italy, Goya applied for his first important commission, painting one of the vaults in the cathedral of Nuestra Señora del Pilar in Saragossa. The committee of works requested him first to complete a study that was to be approved by the Madrid Royal Academy. But Goya's design was so powerful that they decided to do without the approval of the Academy. With a helper to grind the colors, he went straight to work on the fresco. He was now able to show that he had not wasted his time in Italy. The fresco's well-balanced composition, the impression of depth and space, and the warm, glowing colors are strongly reminiscent of Late Baroque ceiling paintings in Italy. There is hardly any sign of individual style, though the slightly sketchy technique is noticeable. Some degree of uncertainty in the representation of figures is also apparent.

Quickly earning a sound reputation as a painter of religious frescoes, Goya completed various commissions in the churches of Saragossa and the surrounding areas. During the 18th century, the Church was the most important source of commissions for paintings after the court, since it had enormous wealth at its disposal. Its power, prestige, and influence were almost limitless; whether beggar or king, anyone who met a priest carrying the consecrated host had to kneel in veneration.

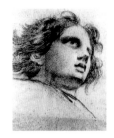

Head of Angel
1772
Crayon
41.5 x 34 cm
Madrid, Prado

The drawing is a study for one of the two angels standing on the left of the fresco opposite. For this drawing Goya copied an engraving of an original drawing by Raphael.

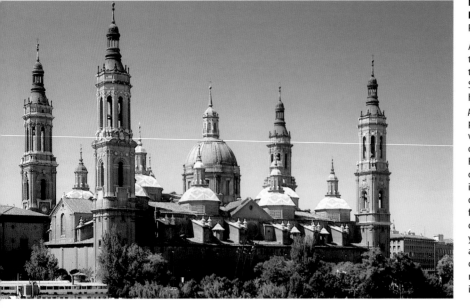

Nuestra Señora del Pilar, Saragossa
Photograph

According to legend, the Virgin appeared to St. James in Saragossa and gave him a pillar (Spanish *pilar*) for this pilgrimage church, which had been dedicated to her. From 1771 the church, dominated by its eleven domes, was decorated with new frescoes. The decoration took ten years to complete, and involved several of the most highly regarded painters in Spain.

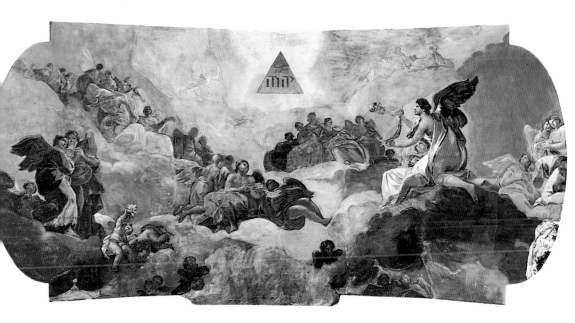

Goya could now live very well from his income; at the age of 27 he was earning almost as much as his teacher Luzán. In 1774 he painted his most extensive cycle of murals in the isolated Carthusian monastery of Aula Dei. They were painted in oil applied directly to the walls, and cover a total area of almost 240 square meters (about 2,580 square feet). Largely forgotten for many years, this cycle on the life of the Virgin Mary is nevertheless among the most interesting of Goya's early works, in spite of its poor condition. Mengs was so taken with the compositions that he had copies of them made.

Adoration of the Name of God
1772
Fresco
ca. 7 x 15 m
Saragossa, Nuestra Señora del Pilar

Angels are massed on banks of clouds that form a triangular space of celestial sky in which hovers the name of God written in Hebrew. In this very

Baroque composition the impression of depth is created by the way in which the figures grow smaller the further away they are. In the distance, the angels almost seem to dissolve in the light. The broad brush strokes used here will also characterize Goya's later work.

Circumcision of Christ
1744
Oil on plaster
310 x 520 cm
Saragossa, Cartuja de Aula Dei

Goya developed a completely new style for the frescoes in the church of the Carthusian Aula Dei monastery. In a background of landscape and architectural features, cloaked figures in ample robes are caught in a stately rhythmic movement. Broad areas of light and shade pick out the figures. Of the original eleven paintings, seven are still extant.

Move to Madrid 1774–1783

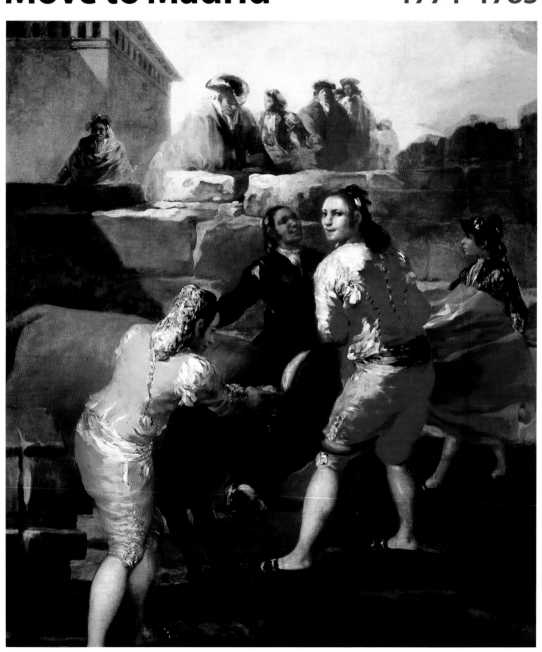

Goya's work unexpectedly took a new turn when, in 1774, Mengs called him to Madrid to work for the Royal Tapestry Manufactory. Instead of painting religious frescoes, his task now was to create designs for tapestries; they were to be everyday scenes. After a few rather conventional compositions, Goya was soon producing lively and attractive, sunny images of Spanish life. He was now, for the first time, working for the royal court, even though only in a subordinate position. The young crown prince and his wife, later King Charles IV of Bourbon and Maria Luisa of Parma, were particularly taken with his work.

It was in the royal palaces that Goya first saw the paintings of the great Spanish artist Diego Velázquez (1599–1660), who was to have a significant influence on the development of Goya's own rather free technique.

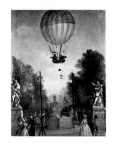

The Montgolfière balloon, 1783

Self-portrait (detail), 1783

1774 Death of Louis XV of France. *The Sorrows of Young Werther* by Goethe.

1776 American Declaration of Independence.

1778 France and Spain in a maritime war against England. Death of Voltaire. Opening of La Scala in Milan.

1780 First calculating machine.

1781 *Critique of Pure Reason* by Emmanuel Kant.

1783 Flight of the first Montgolfier brothers' balloons.

1774 Anton Raphael Mengs calls Goya to Madrid.

1775 Goya works on his first series of tapestry designs for the royal palace in the Escorial.

1776 Works on the second series of tapestry designs, this time for the El Pardo Palace.

1778 Makes engravings of paintings by Velázquez. Further tapestry designs for the El Pardo Palace.

1780 Is accepted into the San Fernando Academy in Madrid.

1781 Dispute with his brother-in-law Francisco Bayeu while working together on the frescoes in Saragossa cathedral. Death of his father.

1781–1783 Works on altar paintings for the church of San Francisco el Grande in Madrid.

Opposite:
Fighting a Young Bull (detail)
1780
Oil on canvas
259 x 136 cm
Madrid, Prado

Right:
Study for Dance on the Banks of the Manzanares
1777
Black chalk
28.9 x 22.5 cm
Madrid, Prado

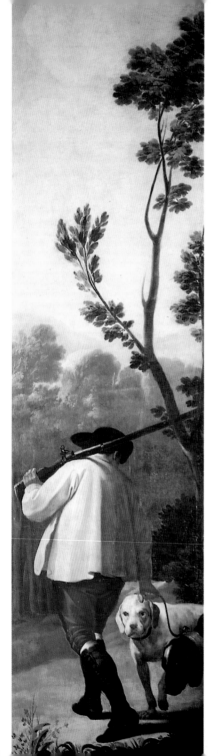

The Royal Tapestries

Francisco Bayeu had undoubtedly used his influence to find a post at the Santa Barbara tapestry manufactory for his brother-in-law, the 28-year-old Goya. After his official invitation from Mengs towards the end of 1774, Goya had resettled in Madrid and, for the next few years, lived at the Bayeu home with his young wife Josefa. He remained in close contact with his childhood friend Zapater in Saragossa, sending him chocolate, wine, and once even a hunting dog. A contemporary observer thus described Madrid at that time as follows: "In the streets black-veiled women, monks, water carriers and fruit sellers hurry about their business. Long-eared, smooth-shaven mules pull every type of vehicle, be it a splendid equipage, a six-in-hand stagecoach, or a cart full of oranges from Valencia."

The Royal Tapestry Manufactory had been founded in 1720 and placed under the management of a specialist from Antwerp. At first, engravings of Dutch genre paintings were used as the designs for the tapestries. Under Mengs' management, young Spanish painters were used to establish original designs. These so-called cartoons – in fact paintings on canvas – were copied on the manufactory looms to create tapestries made from fine thread dyed in every nuance of color. They were destined to become the sumptuous wall decoration in the

The unusually narrow shape of this tapestry cartoon corresponds to the area to be covered by the tapestry, in the crown prince's dining room in the San Lorenzo castle in the Escorial. The design is from Goya's first series of tapestry cartoons. The nine pictures in the series show hunting scenes in wooded landscapes; they were completed under the supervision of his brother-in-law Bayeu and in collaboration with the latter's brother, Ramón. It is not surprising, therefore, that the rather dry technique is reminiscent of Bayeu's works. Also, the range of themes is traditional. It is obvious that Goya was trying to restrict himself to a few colors and clearly outlined areas so that the conversion of the design into a tapestry would be easier.

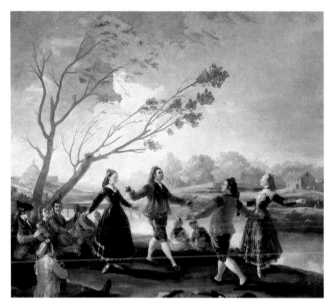

colors. However, these pictures have little to do with a realistic representation of the life of the people: they give the impression that life is nothing but pleasure and play. Even work is done with the light-heartedness and grace of a pastime. The austere Mengs observed: "Don Francisco Goya … is an artist of spirit and talent who will make great progress in the arts if he receives the generous support of the royal family." In a period of five years Goya supplied a total of 39 designs.

Dance on the Banks of the Manzanares
1777
Oil on canvas
272 x 295 cm
Madrid, Prado

Goya himself described the scene: "Two majos and two majas are dancing the seguidilla, two others are playing the music and one of these is singing to the guitar… in the distance you can see Madrid, with the church of San Fernando." Majos were stylish young men from the lower strata of society, proud, fashion-conscious toughs who wore colorful traditional dress. Majas were their female counterparts.

royal family's palaces, where they also served as insulation against the cold in winter. Goya designed an initial series of cartoons under the immediate supervision of his brother-in-law, as he had no experience in this new trade. The second series, however, was entirely of his own conception. The crown prince and his wife wanted typical Spanish folk themes for their rooms in the El Pardo Palace, a task completely in tune with Goya's own inclinations. He designed a bright, happy medley of folk scenes: dancing and ball games, traveling peddlers and men on stilts, wood cutters and washer-women, children's games and bull-fights. His artistic confidence increased rapidly while he was working on the tapestry cartoons, which are well-balanced compositions painted in fresh, luminous

Filippo Juvarra and Giovanni Battista Sacchetti
Madrid, Palacio Real, Campo del Moro façade, 1735–1764
Photograph

The Parasol

For the aristocracy, the life of the people was an attractive and accessible way of "playing" at life. It amused them, they enjoyed watching the life of the people, portraying it, joining in for a few moments, specifically because it was something different.

José Ortega y Gasset

Women play an important part in Goya's tapestry designs. Full of confidence, they dance and flirt with the men, sell oranges or flowers, wash linen, or just take their ease languorously. The observer is drawn into the game of coquetry that has its own elaborate vocabulary of looks and gestures. The young woman in the famous painting *The Parasol* (opposite) is sitting in a sedate pose, her smile charming and flirtatious. The tapestry was intended for a wall above a door, which is why Goya placed the young beauty on a grassy hummock from which, fully aware of her beauty, she looks down on the observer, delighted at the opportunity to display her charms. Her companion is using the parasol to protect her delicate skin from the sun. In her hand she is holding a closed fan – an indispensable accessory for Spanish women in Goya's time – as if it were a royal scepter. The often brightly and sumptuously decorated fan was not used solely to create a cool current of air: it was also used as a means of communication, as every movement, every opening and closing of the fan, had its significance. This language, known to every level of society, meant that women could give a secret sign of encouragement to the man of her choice, or indicate her lack of interest. A lapdog was a fashion accessory for elegant women. As a recognized symbol of fidelity, the dog was also a traditional element in portraits of women. Here, however, the normally alert protector of feminine virtue is curled up asleep on the young woman's lap while she looks out almost invitingly. Goya repeatedly used the theme of the relationship between men and women, happy or despairing, in every possible combination. In the late painting *The Letter* (below left), a beautiful woman steps out of the shade of the parasol into the full daylight while she looks slightly mockingly at the letter she is holding in her hand. In this picture too the little dog, here begging for attention, is a comment on the painting's theme.

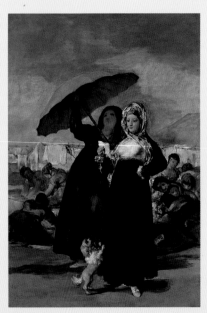

Left:
The Letter
1812–1814
Oil on canvas
181 x 122 cm
Lille, Musée des Beaux Arts

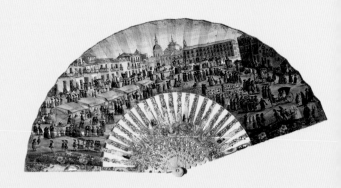

Above:
Painted Spanish fan,
ca. 1789

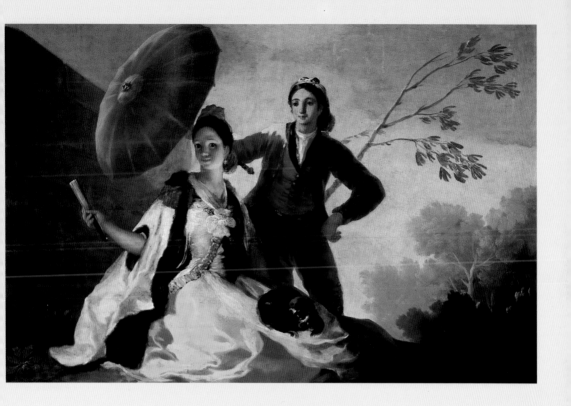

Light and color

The happy, intimate atmosphere of *The Parasol* is created not least by the skillful color composition. The silky yellow of her dress, the light blue of her bodice, the bright red of her headdress and the man's waistcoat, and the rich green of the parasol form a harmonious combination of luminous tones that give a clear emphasis to the two figures. The background is a vague setting of subdued tones of blue and green that contrasts with the rich harmonies of color in the foreground. Goya applied the color generously and energetically. However, it is the effect of the light that is most remarkable, since it gives this scene an almost impressionistic quality. The areas of light and shade contrast sharply. The young man is almost completely bathed in shadow, with light from the left falling onto his face and shoulder. In contrast, the woman's elegant dress glows in full sunlight, while her face remains in the shade of the parasol. Her softly modeled features are lit gently from below by the reflected light from her clothes. The virtuosity of the interaction of light, shade, and color recalls Tiepolo's frescoes. It is only at second glance that we notice the strangely ominous wall to the left, behind which dark clouds are massing. However, the diagonal it creates soon leads our gaze directly to the face of the young woman, whose eyes are gazing at us intently.

The Parasol
1777
Oil on canvas
104 x 152 cm
Madrid, Prado

Goya's palette

Tradition and Independence

Competition with artistic precursors was always of immense significance to Goya. He himself once said, later, that he had no teachers other than the most famous paintings in Italy and Spain, from which he had learnt almost everything. At the beginning of his career he had no desire to make a stand against convention and tradition. On the contrary, he often based his work closely on earlier and contemporary models in order to improve his own skills. Later he continued to use such models but now gave them a fresh interpretation, introducing completely new relationships between quoted imagery and his own realistic observations. On July 29, 1778, an advertisement in the newspaper *Gaceta de Madrid* advertised nine etchings after paintings by Velázquez, "engraved by Don Francisco Goya." This series documents Goya's first intensive encounter with Velázquez' work. Encouraged by Mengs, who recommended young painters to study Velázquez, Goya had begun to study paintings by the latter in the royal collections, and to make engravings of them. Before the invention of photography, prints were the only means of reproducing paintings. During this process, a painting's nuances of color had to be converted into lines, hatching, and contours. Goya initially made precise drawings of the paintings, which he then etched on copper plates in order to make prints of them.

Velázquez understood as no other painter did how to reproduce light and air with paintbrush and color. His light touch and open technique appealed to Goya, who was already tending to use freer brushstrokes.

However, several decades were to pass before Goya developed a completely independent style. His development was in fact unusually slow and full of contradictions and surprising disruptions. Whenever his career demanded it, he did not hesitate to conform to the prevailing conventions. His submission for entry to the Madrid Academy of Art, the painting of *Christ on the Cross* (opposite), illustrates this clearly.

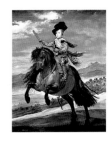

Diego Velázquez
Prince Balthasar Carlos on Horseback
ca. 1635
Oil on canvas
209 x 174 cm
Madrid, Prado

Velázquez painted the portrait of the young heir to the throne, together with four other equestrian portraits, for a room in the Buen Retiro Palace.

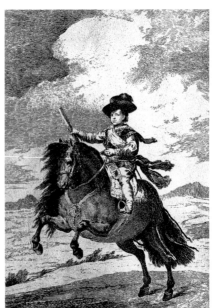

Prince Balthasar Carlos on Horseback
(after Velázquez)
1778
Etching
35 x 23 cm
Madrid, Prado

Goya's copy of Velázquez' painting is not identical in every detail. He tried to reproduce the latter's brush strokes with light lines full of movement. But when converting the rich color of the painting into the black and white of a print, he changed the background so as to bring the figure into stronger relief.

In 1780 this smooth, academic image earned him a place in the Academy, a very important institution, and so made it possible for him to reach influential aristocratic patrons.

In the same year, having just proved himself to be a good academician with this Crucifixion, Goya quarreled with his brother-in-law, Bayeu, while they were working together on a fresco commission. The older Bayeu probably found Goya's technique too light; the commissioners of works also rejected Goya's designs, and he had to make alterations.

At this period, Goya had already moved with his family to his own house in the Calle del Desengaño, in northeast Madrid; it was here that he kept his studio for over 20 years.

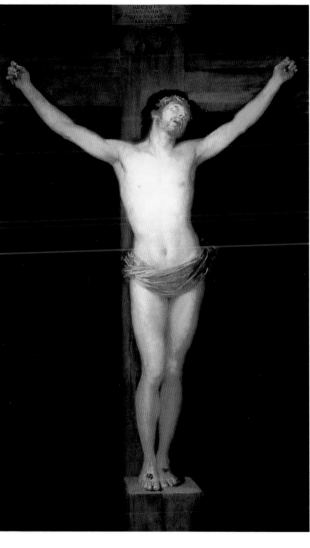

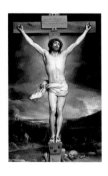

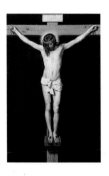

Anton Raphael Mengs
Christ on the Cross
1761–1769
Oil on canvas
198 x 115 cm
Madrid, Prado

Diego Velázquez
Christ on the Cross
ca. 1613
Oil on canvas
100 x 57 cm
Madrid, Prado

Christ on the Cross
1780
Oil on wood
255 x 153 cm
Madrid, Prado

With this painting, Goya kept closely to the traditional image of Velázquez and Mengs. From Velázquez he adopted the plain dark background; from Mengs he took the posture and attitude of Christ. Goya made every effort to achieve the highly finished execution that was the academic ideal. Never again was he to paint a religious painting with such a smooth, perfect, and impersonal effect.

Artist to Nobility 1783–1791

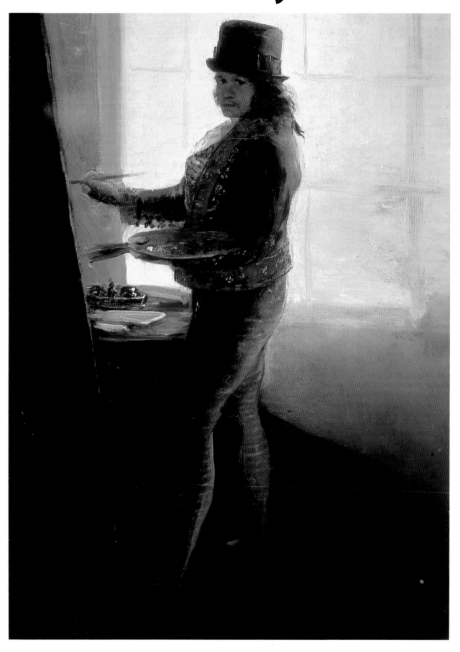

After Goya had become a member of the Madrid Academy he turned his attention to finding new patrons in Madrid's high society.

An important step to this end was the official portrait that Count Floridablanca, the king's first minister, commissioned from him. Goya, who till now had had little opportunity to paint portraits, was soon to become one of the most sought-after portraitists in Madrid, particularly among the aristocracy. He was noticed by wealthy patrons who were willing to pay prices Goya would previously never have dreamed of asking. In addition to his portraits, Goya also designed more tapestries for the Royal Manufactory. At 40, Goya was entering a successful, happy, and carefree period of his life. His social position became more stable when, after Charles IV's accession to the throne, he was appointed Court Painter and commissioned to paint the official portrait of the new royal couple, Charles IV and Maria Luisa.

The storming of the Bastille

Self-Portrait at 37

1783 In England, a process for faster steel production is invented.

1785 In England, *The Times* is first published.

1786 Death of Frederick II of Prussia.

1787 Premiere of Mozart's opera *Don Giovanni*, in Venice.

1789 The storming of the Bastille, which begins the French Revolution. George Washington becomes the first President of the USA. Coronation of Charles IV and Maria Luisa in Spain.

1791 In Poland, the first written constitution in Europe is adopted.

1792 An early form of telegraph is developed.

1783 Goya paints Portrait of Count Floridablanca. Spends a period with Don Luis de Borbón, where he paints a family portrait.

1784 Birth of his son, Francisco Javier Goya.

1785 First commission from the Dukes of Osuna.

1786 Appointed a painter to the king; begins a new series of tapestry designs for the El Pardo Palace.

1788 *Portrait of Charles III*

1789 Rises to the position of Court Painter. Paints the portrait of the new royal couple, Charles IV and Maria Luisa.

1791 Works on his last tapestry designs.

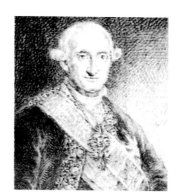

Opposite:
Self-Portrait
1790–1795
Oil on canvas
42 x 23 cm
Madrid, Real Academia

Right:
Portrait of Charles IV
1789
Pencil on paper
10.2 x 6.3 cm
Madrid, Carderera Collection

Goya's First Patrons

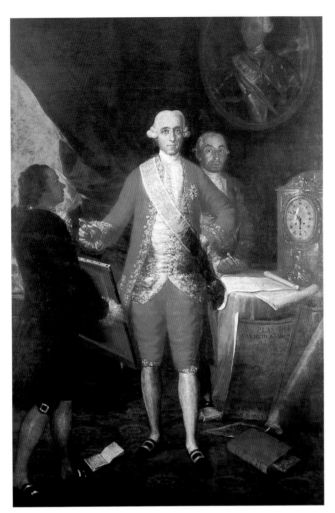

In 1786 Goya wrote to his friend Martin Zapater: "I have now established myself in a most enviable manner. Those who require something of me must seek me out – I remain apart. I work for no one unless he is a high ranking personality or a friend. Yet the more I play hard to get, the less they leave me in peace, and I do not know how I am to proceed." This was an astonishing achievement for a painter from the provinces who, just a few years before, had been glad of employment as a tapestry designer.

An important step on his road to being the leading portraitist of Madrid high society was the large portrait commissioned by Count Floridablanca (left), one of the most influential men in Spain. There was a great demand for impressive portraits from the aristocracy, since images displaying their status were an important part of their family traditions. In contrast to the often-penniless hidalgos, the higher aristocracy, to which the 119 families of the so-called "grandees" belonged, possessed immeasurable wealth. One of Goya's first patrons, Don Luis de Borbón, lived apart from the Madrid court, at his country seat, because, as the king's brother, he had married a woman from the lower aristocracy. He had himself and his family painted by Goya, and invited the painter to spend the summers of 1783 and 1784 at his home. "These princes are angels," Goya wrote to

Portrait of Count Floridablanca
1783
Oil on canvas
262 x 166 cm
Madrid, Banco de España

Goya's career as painter to the aristocracy began with this life-sized portrait of Secretary of State Floridablanca. Though still a rather stiff composition, the painting nevertheless complies with the expectation for an imposing official portrait. The luminous red stresses the power of the count. The maps indicate his project for a canal in the province of Aragon; a book on the art of painting shows him to be a connoisseur of art. Goya has painted himself (on the left of the painting) as a courtier presenting the count with a painting for his approval.

Portrait of the Duke of Osuna's Family
ca. 1789
Oil on canvas
225 x 174 cm
Madrid, Prado

The Dukes of Osuna belonged to the highest ranks of the Spanish aristocracy. The Duchess was one of the most brilliant women in Madrid and dressed elegantly, in the latest Paris fashion, and the salons she and her husband arranged were frequented by artists, intellectuals, and writers. The Duchess, an enthusiastic and open-minded connoisseur of new art, valued Goya's work very highly. In this large format portrait, Goya shows the family not in their luxurious palace but set against an indeterminate background that brings the individuals out in sharp relief. With the children unaffectedly holding their toys in their hands, the family portrait is at once intimate and yet dignified.

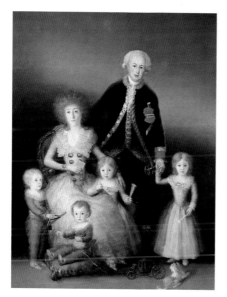

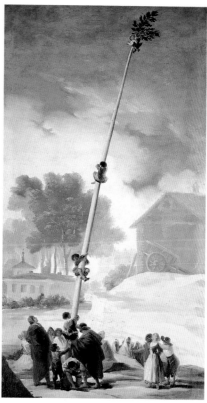

his friend Zapater. He invested his fee, the fantastic sum of 30,000 reales, in shares.

Among Goya's most faithful benefactors were the Dukes of Osuna, who over the years ordered 30 paintings from him. Goya could now afford a splendid lifestyle, with elegant clothes and a fashionable carriage. For Goya himself a new world was opening up. Till now he had basically been an unpolished, uncultivated artisan, who saw his work as an elevated form of craftsmanship and who instinctively enjoyed the pleasures of the simpler classes. In the trend-setting circles of Spanish society he began to view completely new cultural and intellectual horizons.

The Greasy Pole
1786–1787
Oil on canvas
169 x 88 cm
Madrid, Duque de Montellano

Goya painted this picture as one of a series of country scenes for the Alameda Palace of the Dukes of Osuna. As with his tapestry designs, it is a depiction not of the entertainment of the aristocracy but of a village festival. Villagers have erected a tall greased pole that the boys are trying to climb. Prizes of chickens and pastries are dangling from the top. The inventiveness of the painting lies not least in the unusually bold use of the tall format. The slender form of the pole reaches far into the blue sky. The subject can be read as a symbol of human life, as well as a simple depiction of a popular form of entertainment.

New Tapestry Designs

In July 1786, Goya reported triumphantly to Zapater, "Martin, I am now painter to the king, at a salary of 15,000 reales!" The new honor was in fact linked with an obligation to supply more designs for tapestries to the Santa Barbara tapestry manufactory, but now he would be paid a fixed annual salary for this.

His first task was to design the décor for the dining room in the El Pardo Palace; the theme was one of the classic themes in art, the four seasons. Goya adopted traditional motifs such as the grape harvest for the autumn, and haymaking for the summer. But he provided these traditional motifs with a wealth of realistic images. The painting for winter,

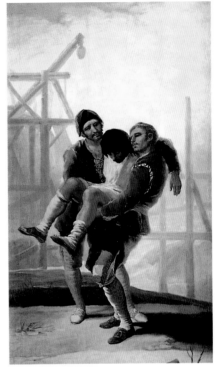

The Injured Mason
(detail)
1786–1787
Oil on canvas
268 x 110 cm
Madrid, Prado

An amazing study by Goya exists for this picture of an injured building worker. In it, exactly the same group of poorly dressed men can be seen, but their gestures show that they are carrying from the site not an injured mason but one who has had too much to drink.

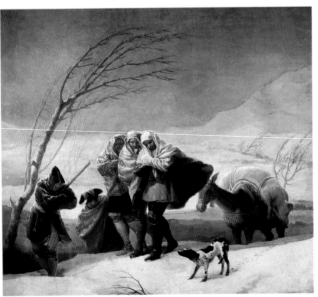

Snow Storm
1786–1788
Oil on canvas
275 x 293 cm
Madrid, Prado

In a winter landscape, peasants cloaked only in thin wraps are struggling through a snowstorm. Behind them, a donkey is trotting, laden with a freshly slaughtered pig. The intense feeling of cold is enhanced by the ice-gray tones. Such an image of harsh weather was certainly an unusual subject for the decoration of a dining room, but it hung opposite a summer harvest scene that, with its warm yellow tones, provided a contrast. When compared with Goya's earlier cartoons, this tapestry design demonstrates a marked stylistic change. Instead of juxtaposing sharply contrasting areas of luminous colors, he is now using more subdued colors that blend into each other.

for example, is a harsh representation of simple people battling against the elements. Next to it hung tapestries depicting a poor woman and her children, and even an injured mason. This new vision of the real world corresponded to an increasing awareness of social questions. A few years before, Charles III had promulgated a law on improving safety on building sites, and had declared that physical work, despite its low status in Spanish society, was not a dishonorable occupation.

When, in 1791, Goya received a commission for a further series of tapestries, he refused it. He was now of the opinion that this kind of work was unworthy of him; after all, since 1789 he had been Court Painter. It was only when there was a threat to cut his salary that he declared himself ready to undertake the commission; but it was to be for the last time. In 1792 he became seriously ill and the series was never completed.

He made his feelings known nonetheless. Some of those tapestry designs he did complete, which were intended for the king's study in the Escorial, reveal a flash of sarcastic humor. In one, for example, laughing young women are throwing into the air a straw manikin that looks like a man without a will of his own (right). Another design shows the guests at a wedding laughing at a mismatched couple: a pretty young girl and an ugly old man. The games of masquerade and deceit between the sexes were to occupy Goya a great deal.

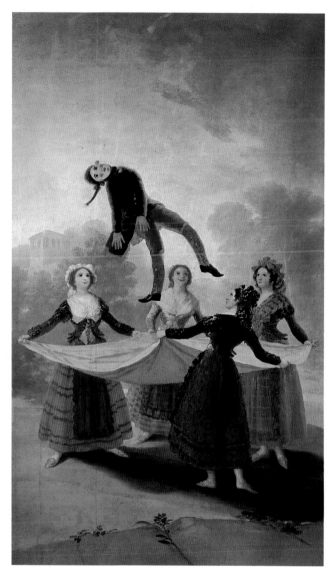

The Straw Manikin
1791–1792
Oil on canvas
267 x 160 cm
Madrid, Prado

This picture, with the life-size dummy and

the mask-like smiles of the women, seems odd and unreal. It is easy to see this scene as the depiction of a traditional theme: men as the playthings of women.

The Festival on San Isidro's Day

Each year, on May 15, the people of Madrid celebrated the festival of their patron, San Isidro. On this day there was a procession to the saint's hermitage on the opposite bank of the Manzanares, to give thanks and make vows. After that came the entertainment, when young and old, rich and poor sat on the meadow by the hermitage. They ate and drank wine and snacks offered by peddlers, and partied late into the night. One of the most popular and important festivals of the year, it was a wonderful theme for the tapestry designs Goya was to supply for the bedroom

of the royal princesses in the El Pardo Palace.
He wrote to Zapater: "The themes are very difficult and require a lot of effort, especially *The Meadow of San Isidro* on the saint's day, with all the disturbance which is generally accepted as normal on these occasions." In one design, the hermitage church can be seen; and a second composition, a panorama, shows the meadow crowded with festively dressed "pilgrims." Because of the death of Charles III, these sketches were never executed as tapestries, but remain intact and were acquired a short time later

by the Duke of Osuna to hang on his walls. This suggests that Goya's contemporaries already valued his oil sketches as independent, legitimate works of art.
The broad format of the design for *The Meadow of San Isidro* shows one of Goya's few landscape scenes. In the late afternoon light of a spring day, we can recognize the outline of Madrid on the other side of the river, from which the block-like royal palace emerges on the left. Further right is the large dome of the church of San Francisco el Grande. On this side of the Manzanares the city's inhabitants have settled on the meadows by the

riverbank and on the hillside in the foreground. In the front row we see elegant women talking, protecting themselves from the sun with their silk parasols. To the right, a brightly dressed maja is pouring out some wine for a young man. Goya depicts the colorful bustle in the center ground almost in the style of a miniature; the coaches of the wealthier Madrid citizens are shown lined up awaiting their owners. Here and there, groups have congregated to dance a lively seguidilla. There is nothing to recall the religious origins of the outing; this pilgrimage is devoted to pleasure. Goya captured the

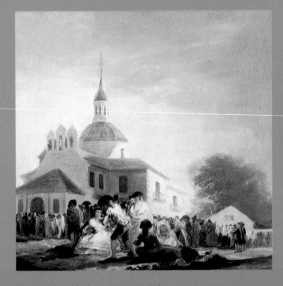

San Isidro Hermitage on Festival Day
1788–1789
Oil on canvas
42 x 44 cm
Madrid, Prado

Above:
The Meadow of San Isidro
(detail)
1788
Oil on canvas
Madrid, Prado

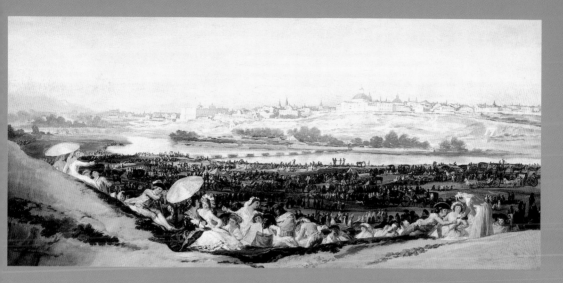

atmosphere of the spring day in soft mother-of-pearl tones. Stronger tones and gleaming white make the figures in the foreground stand out, while the outlines of the city in the background are limited to subtle shades of light blue, pink, green, and ivory. This finely harmonized color scheme also lends the landscape a strong sense of perspective.

About 35 years later Goya created a dark contrast to this bright impression of San Isidro's Day, when he painted the walls of his own country house with his oppressive black paintings (page 79). Similarly, the composition he selected for the *Pilgrimage of San Isidro* (below) was also an extremely broad format, but the happy, peaceful world of the tapestry design has been replaced by one of inconsolable gloom. The pilgrims are now crowded together, jostling in a huddled procession that is coming out of the picture towards us. The gaping mouths of the distorted faces are open in a gruesome song. This submissive, fanatical mass of humanity seems no longer capable of any rational action.

The Meadow of San Isidro
1788
Oil on canvas
44 x 94 cm
Madrid, Prado

Pilgrimage to San Isidro
1820–1823
Oil on plaster, transferred to canvas
140 x 438 cm
Madrid, Prado

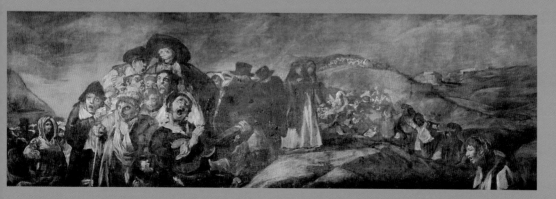

Goya and Children

I have a four-year-old son who is so beautiful that people in the streets of Madrid turn round to look at him. He was so ill that I stopped living for that whole period. Thank God he's better now.

Goya to Martin Zapater

Children's lives, children's games

Between 1775 and 1784, Goya's wife Josefa gave birth to six children, but only the last-born son, Javier, survived. Goya always had a special relationship with children; he painted his grandson Mariano several times and even at an advanced age he drew pictures for the daughter of Leocadia Weiss, his companion. His first portraits of children were executed for aristocratic patrons who wanted to have portraits of their heirs as well as of themselves. Goya's first child portrait, painted in 1783, was of Maria Teresa, the two-year-old daughter of his patron Don Luis de Borbón. Many years later he painted her a second time, as the young Countess of Chinchón (page 57).

The portrait of the four-year-old Manuel Osorio is one of Goya's most famous works (opposite, top right). The luminous red of his costume makes the pale, serious-looking boy, who was at that time the same age as Goya's own son, look all the more delicate. The background is indistinct. The light falls diagonally, emphasizing the boy's head. Goya added his signature to the card held in the magpie's beak. Three cats are staring through the darkness at the magpie,

Portrait of Mariano Goya
ca. 1815
Oil on wood
59 x 47 cm
Madrid, private collection

which the boy is holding on a thin lead. Is this a reference to the passing of childhood innocence, and the captive bird a symbol of the child's restricted freedom? Perhaps; but we have to remember that in those days it was perfectly normal to give children animals as playthings.

Goya was able to capture the child's personality with great sensitivity, transcending the purely representational portrayal. His portraits always show a great deal of tenderness for children, who were expected to display fitting dignity and composure from a very early age. The contrast between the child as a child, and the child as an actor in the

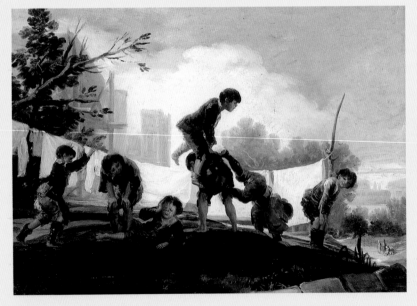

Children's Games
1777–1785
Oil on canvas
29 x 41 cm
Valencia, Museo de Bellas Artes

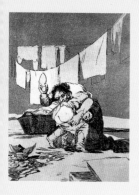

But he broke the vase
Capricho No. 25
1797–1798
Etching and aquatint
20 x 15 cm

Here comes the bogeyman
Capricho No. 3
1797–1798
Etching and aquatint
21.7 x 15.3 cm

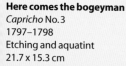

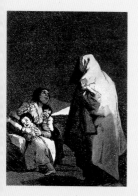

elaborate and imposing ceremonies that were an inescapable aspect of court life had already been demonstrated by Velázquez in his portraits of the royal children. Goya had studied these works in detail (page 58).

Goya also depicted the children of the lower social orders in small genre paintings and tapestry designs. Not as pampered as the children of the aristocracy, they romp about in ragged clothing, under the open sky; they scuffle and tussle, they play leapfrog, and steal eggs from birds' nests. Often their games imitate the life of the grown-ups: they play soldiers and bullfighters. In the 17th century the Spanish painter Bartolomé Esteban Murillo (1618–1682) had used street children, eating or playing, as subjects for his paintings. Goya's paintings, however, are more in the tradition of the Dutch genre paintings, which were known in Spain.

The terrors of childhood

But Goya also expressed the darker aspects of childhood. Even in his official portraits of children there is often something like sadness in their expression, or a look of surprised incomprehension of the adult world. Every adult can remember the fears of childhood, the fear of punishment or of inexplicable things, of the bogeyman or darkness. Goya tries to depict these fears in several of the pages of his series of *Caprichos*. At the same time, he implies

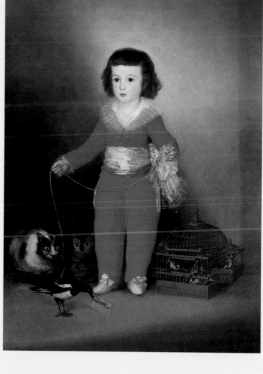

criticism of brutal and absurd methods of child-rearing, and exposes adults who exploit their power over children. On one page, entitled *But he broke the vase*, an angry old woman is thrashing her child as though possessed (top left). Goya's laconic comment is: "The son is naughty, the mother bad-tempered. Which is worse?" Another page shows the terror of a child confronted with a weird figure draped in a white cloth, a figure used by adults to frighten children (bottom left).

In Goya's time there was a good deal of discussion in Spain about the child-

Portrait of Don Manuel Osorio Manrique de Zúñiga
1788
Oil on canvas
127 x 110 cm
New York, Metropolitan Museum of Art

rearing reforms of the Enlightenment. He himself designed the title page for the Spanish edition of a book by the Swiss reformist teacher Johann Pestalozzi (1746–1827), and he painted a shield for the Royal Pestalozzi School founded in Madrid in 1806.

At the Spanish Court

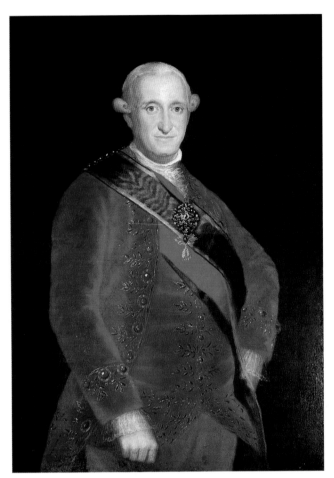

On September 21, 1789, Madrid embarked on a sumptuous festival. Streets and houses were decorated, and the aristocracy had triumphal arches and sets built in front of their palaces. For three days and nights, the people and the aristocracy celebrated the accession of Charles IV and his wife Maria Luisa.

Under Charles IV Goya was to achieve the highest honors. However, the new regime was to bring decline and chaos to Spain. Politics turned not on the well-being of the country, but on the changing moods of the king, for whom expediency was a principle of government. Little influence was felt in Spain from the turbulence of the French Revolution, during which the populace went to the barricades against their king.

Charles III, who had died during the previous autumn, had been an enlightened monarch who had tried to modernize his country. The Bourbon king had ascended the throne in 1759, when Goya was 13 years old. He had had street-lights and drains installed in the dirty, dark quarters of Madrid. The classical buildings he built still edify Madrid, even today. Science and art, trade and crafts all experienced an upsurge through his reforms.

At the time Spain was widely seen to be the most backward country in Europe, held back by the weight of unbending tradition and the jealously guarded power of the Church. Nevertheless, Spain still had an

Portrait of Charles IV
1789
Oil on canvas
220 x 140 cm
Madrid, Academia de Historia

Charles IV was 40 years old when he ascended the Spanish throne in 1789. He was known as a passionate huntsman, strong and healthy – and not very intelligent. He left the affairs of state mainly to his lively wife Maria Luisa, who was conscious of their power.
In the area of the fine arts, his principal contribution was the maintenance and documentation of the royal collections. However, he also supported many painters through the appointment of court painters, whose main task was to decorate his palaces and paint portraits. The official portrait of Charles IV was executed on the occasion of his coronation. Goya painted several very similar portraits of the king with the help of assistants.

empire on which the sun never set, and its colonies were wealthy. Life at the Spanish court had been strictly regulated since the 16th century. Year in and year out, the royal family spent the winter at the city palace in Madrid; they moved in January to the hunting lodge at El Pardo, stayed till Easter at the Aranjuez residence, spent the summer at La Granja, and in autumn went to the enormous, dark monastery and palace complex of the Escorial, where the tombs of the Spanish kings were also to be found.

As a tapestry designer, Goya had been one of the "royal painters" to Charles III. But his real court career started when Charles IV ascended the throne. The new royal couple were already ordering an official royal portrait from him as preparations were being made for the coronation. In the same year, 1789, Goya rose to be *Pintor de Cámara*, Royal Court Painter. Ten years later he was to become the king's First Court Painter.

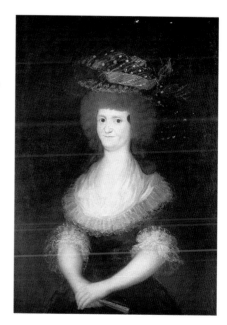

Portrait of Queen Maria Luisa
1789
Oil on canvas
152 x 110 cm
Madrid, Museo Lazaro Galdiano

During the festivities for the coronation, Goya painted Maria Luisa wearing a sumptuous dress and an exuberant feather hat in the French style. Contemporaries and historians do not give a favorable account of the queen: she was known for her vanity, her political intrigues, and for love affairs with young men.

Santiago Bonavia and Francisco Sabatini
Palacio de Aranjuez, main façade with lateral wings
1748–1771
Photograph

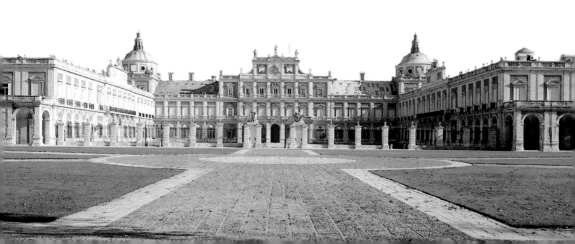

Crisis and a New Start 1792–1798

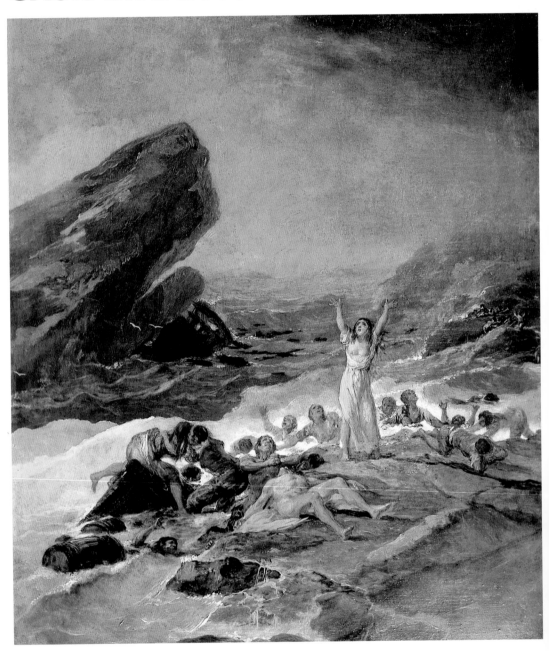

The year 1793 marked a significant change in Goya's career. A severe illness provoked a physical and mental crisis that changed him permanently. The illness left him stone-deaf. The proud society painter, confident and daring, became a man who looked at reality with a far more critical eye. Deafness made him mistrustful of people, but also sharpened his visual perception. He could no longer ignore life's darker side – and no longer wanted to. As a result he began taking the internal world of his imagination increasingly seriously. A passionate affair with the capricious Duchess of Alba brought confusion to his private life; the happiness and despair of this short, violent love affair are reflected in several drawings and paintings. Goya, who was now approaching 50, was less prepared to tailor his art to what was expected of him.

A steam engine in a coal mine, 1792

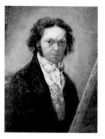

Self-Portrait, 1795–1797

1792 In Britain, Mary Wollstonecraft demands equal rights for women.

1793 The last woman in Europe to be executed for witchcraft is burned.

1793–94 In France, the Terror rages under the Jacobin Robespierre.

1795 Godoy brokers a treaty between France and Spain. Emmanuel Kant: *On Perpetual Peace*

1797 Lithography is invented.

1798 Construction of the first high-pressure steam engine.

1792 Goya travels to Andalusia; he falls seriously ill and loses his hearing.

1793 Paints small cabinet pictures.

1795 Death of Goya's brother-in-law, Francisco Bayeu. Appointed Director of Painting at the Madrid Academy. First portrait of the Duchess of Alba.

1796 Stays at the country seat of the Duchess of Alba in Andalusia.

1797 Back in Madrid in April. Starts work on the *Caprichos.* Withdraws from his teaching obligations at the Academy because of his deafness.

1798 Paints frescoes in the church of San Antonio de la Florida, and an altar painting for Toledo Cathedral.

Opposite:
The Shipwreck
1793–1794
Oil on zinc
50 x 32 cm
Madrid, Palacio Real

Right:
Maja with Beggarwoman
1796–1797
Ink and wash
23.4 x 14.5 cm
Madrid, Biblioteca Nacional

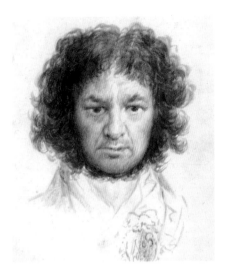

Self-Portrait
1795–1797
Ink and wash
23.5 x 14.4 cm
New York,
Metropolitan
Museum of Art

Goya stares intently at his reflection in the mirror, as though he were trying to plumb the depths of his being. After his physical and psychological crisis, the deaf Goya viewed himself and his contemporaries with a deep mistrust.

Goya A su Amigo Martin Zapater, 1797

Sojourn in Andalusia

The nature of his illness is appalling and I look to his recovery with great sadness.

Francisco Bayeu to Martin Zapater

Portrait of Martin Zapater
1797
Oil on canvas
83 x 64 cm
Bilbao, Museo Bellas Artes

In November 1792 Goya, seriously ill, arrived at the home in Cadiz of the wealthy businessman Sebastian Martínez. He was suffering from attacks of dizziness, loss of balance, and deafness. In bed for a full two months, he was afraid he was going mad. When the crisis was over he was permanently deaf. Goya's illness has never been explained; suppositions extend from syphilis to schizophrenia. It is probable that lead poisoning had a role to play, as Goya used large quantities of the highly poisonous pigment white lead, and was probably not very careful with it.

In addition to this, the purpose of his trip to Andalusia remains a mystery. There are only vague references to this in the letters between his friend Martin Zapater and his

Portrait of Sebastian Martinez
1792
Oil on canvas
93 x 67.5 cm
New York,
Metropolitan
Museum of Art

The painting shows the businessman as a sensitive thinker. It was completed before Goya's illness, which held him captive for months in his friend's house, where he was able to study the latter's art collection.

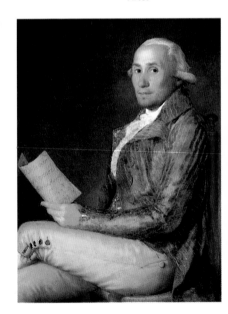

brother-in-law Francisco Bayeu during his illness. In October 1792 Goya was still busy at the Academy in Madrid. He must have left the capital soon afterwards, without applying for official leave from the court. In the summer of 1793 he was back in Madrid but had neither the strength nor the inclination to work on the tapestry designs he had left unfinished. Instead, he painted a series of small cabinet pictures, without a commission, to distract himself from dwelling on his illness.

It was now that he began to use personal experiences and ideas as subjects for his painting. To explain this approach, unusual at the time, he wrote to the members of the Madrid Academy that he had been able to "make observations that are generally not allowed in commissioned works, and in which caprice [capricho] and invention have free play." In these paintings he represents recollections of his journey, including bullfights and scenes from street theaters; other images show huge fires at night, a shipwreck, highway robbery, and a lunatic asylum. The recurrent theme of these paintings is the power that the unpredictable forces of nature have over man; several deal with the borderline between life and death, sanity and madness. This is where Goya's real work began, work that was to make him one of the major precursors of modern art.

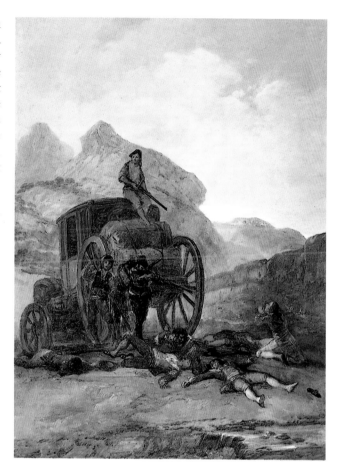

Bandits Attack a Coach
1793–1794
Oil on zinc
50 x 32 cm
Madrid, Marques de Castro Serma

This painting belongs to the series of small works Goya painted just after his illness. It shows highway robbers attacking a coach in a lonely mountain landscape.

One of the bandits is standing guard on the roof of the coach while the others are dispatching the passengers with knives and guns. Goya may have heard about such events during his journey to Andalusia. A few years previously he had already used this subject in a painting for the Duke of Osuna.

The two pictures are similar in terms of composition. But the earlier painting seems anecdotal, almost like a scene from a play. This painting, by comparison, is more realistic and conveys the true brutality of the incident more honestly.

The Duchess of Alba

As for Cayetana, meanwhile, she was born of the heights where freedom reigned, foolishly and splendidly free of those fears that bind and torment all those who were not born to such dizzy heights. And he was full of envious admiration because she was as she was, so foolish and so fearless… and he was aware, at a deeper level than before, that he would never be free of the woman.

Lion Feuchtwanger, *Goya*

The duchess and the painter

She was one of the most famous and most fascinating women in Spain. A capricious beauty and a grandee of unbending pride, she was descended from one of the oldest aristocratic families in the country – the Duchess Cayetana de Alba. She became Goya's most famous model and his passionate love.

In 1795, Goya received a commission to execute full portraits of the Duchess and her husband. In a delicate white dress with a burning red sash around the narrow waist, the Duchess of Alba stands in front of a broad landscape. Her billowing black hair falling to her shoulders, she seems for Goya the very image of sensual beauty. It is possible that Goya fell in love with her then. Her gaze, however, is distant, almost without expression.

Her husband died in June of the following year. The intense relationship between Cayetana and Goya must have begun shortly afterwards. Goya had returned to Andalusia in May 1796 to carry out commissions for the Church,

Portrait of the Duchess of Alba
1795
Oil on canvas
194 x 130 cm
Madrid, Duke of Alba

Volaverunt
Capricho No. 61
1798
Etching and aquatint
21.7 x 15.2 cm

to visit friends, and to study art treasures in Seville and Cadiz. The innocent trip took a fateful turn when the duchess invited him to spend some time at her country seat in Sanlucar, Andalusia, where she was spending her period of mourning. During his time with her he filled his sketchbook with drawings that give a direct insight into the happiness of their passionate relationship. Or are these merely the results of his unrequited desire for her? The affair is disputed to this day. Spontaneous, perfunctory ink drawings show the duchess going for a walk, or lightly dressed at her morning toilet; they also show other young women captured in natural, sometimes intimate, poses. A second portrait of the duchess was executed in 1797. Again, the Duchess is standing upright, in the open air, but instead of the

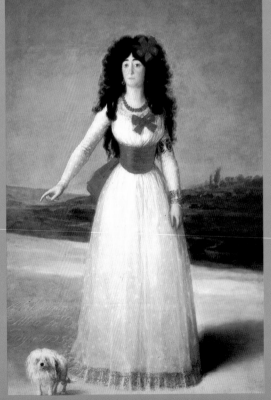

maidenly white, she is wearing the black dress of a maja, with a black lace mantilla framing her ivory-colored face. It had become fashionable with the Spanish aristocracy to adopt the popular style of the majas, who in their typical costume were seen as the essence of the true, unchanging Spain. The majas were famous – renowned for their pride, their unaccountability, and their great beauty.

The duchess points authoritatively to the words at her feet. There, written in the sand, are the words "Solo Goya" (Only Goya). This seems like an open admission of their passion, though the consummation may well have been more a figment of Goya's passionate imagination than factual reality.

The sickness of love

The 33-year-old beauty and an aging, deaf painter… In Goya's sketchbook the relaxed, high-spirited drawings are succeeded by sarcastic caricatures and dark visions.

The passionate affair became a tortured nightmare. His honor mortally wounded, Goya's drawings, and subsequently his prints, took aim at the tragi-comic aspects of life – at human passion, at the coquetry, deceit and unfaithfulness of women, at the ridiculous behavior of their suitors.

On page after page women are depicted as seductive witches, or indeed as incomprehensible, demonic beings. One sheet shows smirking witches carrying off a female figure through the air: her face bears Cayetana's features (opposite, top right). This sheet bears the Latin title *Volaverunt* ("they have flown away"), which in Spain at that time meant "gone and forgotten."

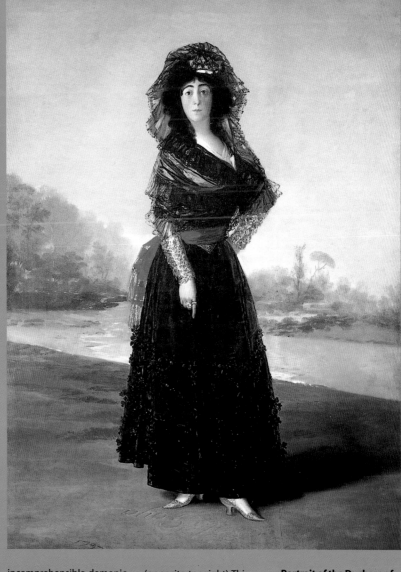

Portrait of the Duchess of Alba, 1797
Oil on canvas
210 x 149.5 cm
New York, The Hispanic Society of America

The Last Church Fresco

Since Goya was now working for the court and aristocracy, he only rarely painted religious pictures. In 1798, however, he created his last great church fresco, for the chapel of San Antonio de la Florida outside the gates of Madrid, a chapel that belonged to the king's estate. Since time immemorial there had been, on the La Florida property, a hermitage dedicated to St. Anthony of Padua. As Royal Court Painter, Goya was commissioned to decorate the chapel and vault of a newly built classical church. At the same time, he was working in his studio on the prints for his *Caprichos*, which made sharp satirical criticism of the Catholic Church.

Goya worked on the frescoes for four months, probably supported by his assistant Asensi Juliá.

Today, Mass is read only once a year in this church – on April 16, the date of Goya's death. Since 1919, San Antonio de la Florida has been a Spanish national monument, and contains Goya's bones, which were brought to Spain from Bordeaux almost 100 years after his death. A copy of the church was built a short distance away, for the cult of St. Anthony.

Goya decided on a composition for which there was no precedent in religious fresco painting. Till then, church domes had always been the preserve of the divine, with floating

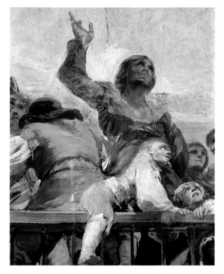

crowds of angels and a representation of God. Goya, however, painted a group of people with the craggy landscape of Spain behind them. The miraculous apparition of St. Anthony almost assumes the nature of an incident in everyday public life.

San Antonio de la Florida, anon.
1792–1793
Etching, 1877

The small church of San Antonio de la Florida contains Goya's most important religious paintings. The frescoes were executed with extraordinary artistic confidence, Goya painting the figures quickly with broad, sweeping brushstrokes.

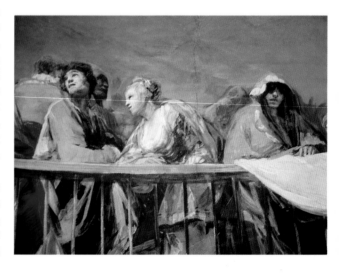

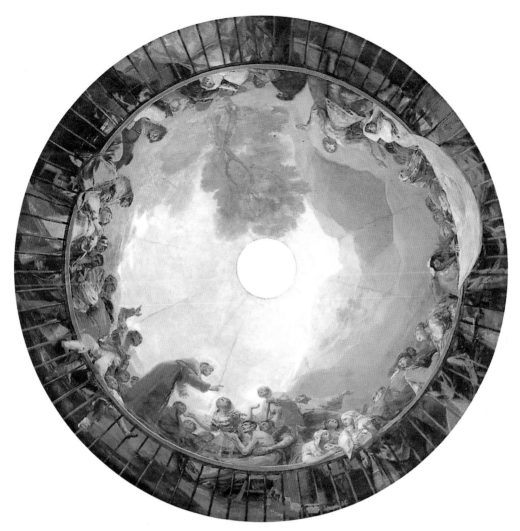

The Miracle of St. Anthony of Padua
1798
Fresco
Diameter 5.5 m
Madrid, San Antonio de la Florida

According to legend, St. Anthony appeared during a court hearing in his native city of Lisbon in order to save his father who had been unjustly accused of murder. At the saint's bidding, the murdered man came back to life and accused the real murderer. Goya moved the setting from the courthouse into the open, and depicted a crowd of people pressing against a painted balustrade. The saint appears in the throng, standing on a rock, above him the empty vault of heaven with only a slender tree to add perspective. In this depiction, the event is no saintly apparition: it seems a down-to-earth event. The spirited figures behind the balustrade, the acrobatic boys, the pensive young women, and powerful men are rooted in the world of Goya's experience and imagination. They are not even paying full attention to the miraculous event, but are acting as they would at a public event, trying to see and be seen.

The Sleep of Reason

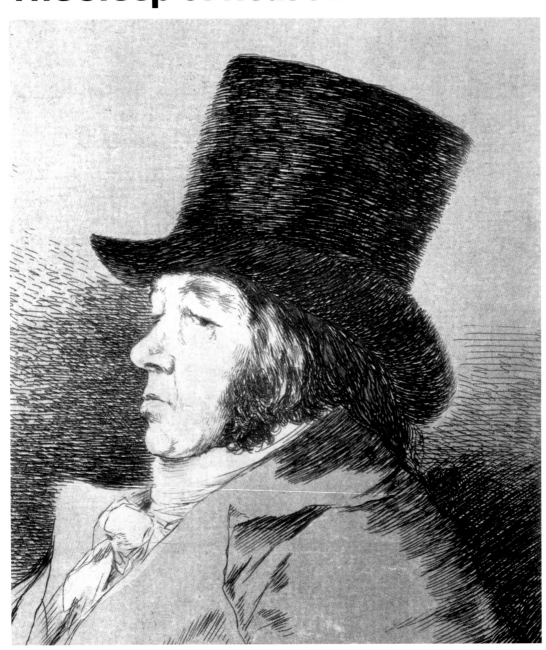

During the final years of the century, Goya created one of his most important works: the *Caprichos*, a series of grotesque, satirical, enigmatic prints. The self-portrait on the title page shows him coolly distant, disillusioned, and a little morose (opposite). The *Caprichos*, a savage critique of social evils and human weakness, are a channel for Goya's personal experience and fantasies. They are also, above all, a reflection of the philosophy of the Enlightenment. Goya was well acquainted with the leading proponents of the new ideas. Although the meaning of individual pages in the *Caprichos* is often unclear, they still address the observer directly, even today, and have lost nothing of their expressive power. Only a few copies were circulated publicly in Goya's lifetime. It was not until after his death that they became known abroad, and were to exercise a strong influence on the art of the 19th and 20th centuries.

Humboldt at the Orinoco

1797 Death of Frederick-William II of Prussia. Madame de Staël gathers Napoleon's opponents at her Paris salon.

1798 Napoleon's Egypt Campaign. Birth of the French painter Eugène Delacroix.

1799 The German explorer Alexander von Humboldt begins his travels through Central and South America.

Goya in 1797, detail of a drawing

1797 Goya puts together albums of studies and caricatures that form the basis for the *Caprichos*. Plans to publish a series of etchings under the title of *Sueños* (Dreams).

1798 Work on the *Caprichos*. Portraits of intellectuals of his day; series of witch paintings for the Duchess of Osuna; drawings for the dictionary of Spanish artists by Bermúdez.

1799 In January a newspaper advertisement publicizes the appearance of the *Caprichos*; after a short time, sales are discontinued.

1803 Goya presents the *Caprichos* to the Royal Institute of Printing, to protect them from the Inquisition.

Opposite:
Self-Portrait
Capricho No. 1
1797–1798
Etching and aquatint
21.9 x 15.2 cm

Right
Caricatures
(detail)
1798
Sepia on paper
29.8 x 40.4 cm

Goya and the Enlightenment

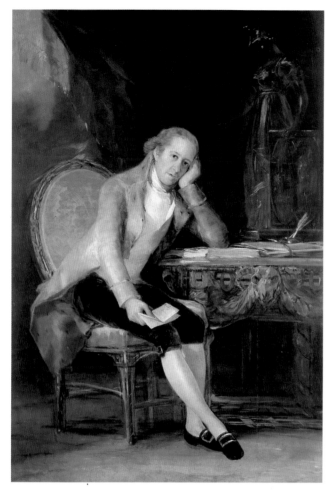

Goya came into contact with the ideas of the Enlightenment through his friendships with liberal intellectuals. In the period after his illness, the *ilustrados* (the "enlightened") introduced him to a new, critical view of the world. Men like Jovellanos, Bermúdez, and Moratín, who were among the leaders of society in Spain, brought him inspiration for his *Caprichos*, a work rich in references, some of them highly ambiguous.

The aim of the Enlightenment, which spread throughout Europe towards the end of the 18th century, was to establish reason as the sole guide to thought and action. Freedom of the press and impartial justice were demanded, and the latest discoveries in science and technology were discussed, as were the current works of literature. In Spain the Church, supported by the Inquisition, strenuously resisted the spread of Enlightenment ideas and so liberalization took longer there than in other countries. Conditions became more critical after the French Revolution. Studying abroad was forbidden, and Enlightenment publications, including works by Voltaire, Jean-Jacques Rousseau, and Denis Diderot, were placed on the Index, the Church's list of banned books. During a temporary period of greater freedom, Goya was able to think about publishing the

Portrait of Gaspar Melchior de Jovellanos
1798
Oil on canvas
205 x 133 cm
Madrid, Vizcondesa de Irueste

The lawyer and man of letters Gaspar Melchior de Jovellanos, Goya's friend, was one of the most important thinkers of the Spanish Enlightenment. He greatly appreciated Goya's art and gave him several important commissions. In 1788 Jovellanos, a liberal, was relieved of his position at the royal court; ten years later, however, he was re-called by Charles IV to be Minister of Justice.

Goya's portrait shows him in 1798, when he was at the height of his power, not as a vigorous politician but as a thoughtful intellectual in a pose traditionally associated with melancholy.

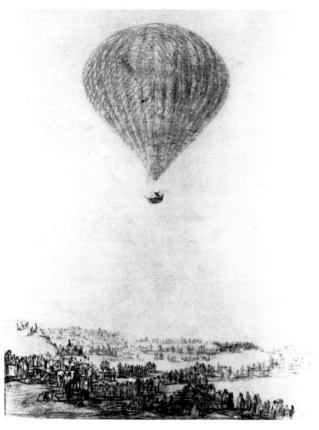

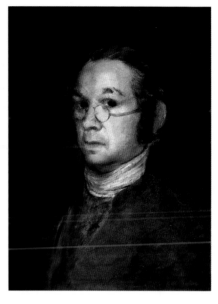

The Montgolfière
ca. 1800–1808
Black chalk
38.3 x 27.3 cm
Hamburg, Kunsthalle

In the 18th century one of the most ancient dreams of the human race was realized: the ability to fly. It was not by sorcery, but through the power of reason that the Montgolfier brothers' balloon rose into the sky. Goya seems to have been fascinated by the idea of flying.

Caprichos. But the intrigues of the court were unpredictable. Barely had reformist politicians taken up influential posts when they were threatened with dismissal, imprisonment, or banishment. Goya's friend Jovellanos, a brilliant legal mind, was banished. In a series of impressive portraits of friends, Goya now portrays the representatives of the Spanish Enlightenment. These, unlike his earlier formal portraits, seek to grasp the individual personality beneath the sitter's rank.

Below:
Portrait of Ceán Bermúdez (detail)
1798–1799
Red chalk
12.2 x 9.8 cm
Madrid, Carderera Heirs

Ceán Bermúdez, a friend of the liberal politician Jovellanos, was one of the most important art historians of the time. Goya planned to illustrate his dictionary of Spanish artists.

Self-Portrait with Eyeglasses
1797–1800
Oil on canvas
63 x 49 cm
Saragossa, Museo Camón Aznar

Goya painted more self-portraits than any other Spanish artist of his time, constantly recording his own image at every stage of his long and varied career. This so-called "intellectual" portrait is the only one in which he depicts himself with his glasses. An admission of this type of physical imperfection was unusual for the time.

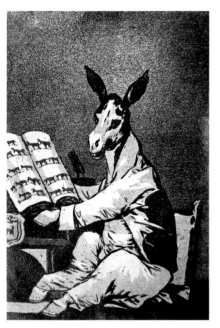

Back to his ancestors
Capricho No. 39
1797–1798
Etching and aquatint
21.5 x 15 cm

The meaning of this print is that anyone who uses their family tree and coat of arms to prove their fine ancestry is an ass - like Queen Maria Luisa, who created genealogical testimonials for her favorite, Godoy. Goya caricatured the behavior of the aristocracy more than once. In doing so, he was continuing an old tradition of satire.

and deception. Obviously, he added, any similarity with living people was purely coincidental. Nevertheless, his contemporaries immediately recognized specific references in many prints. Biting social satire and demonic fantasy combine in the *Caprichos* to create a nightmare from which there is no escape. Goya had envisaged good sales and had printed 300 copies. However, he was very quickly forced to stop sales; a few years later, to protect his work from the Inquisition, he gave the rest of the edition, together with the plates, to the Royal Institute of Printing and in return requested a bursary for his son Javier.

The *Caprichos*

In the perfume and liquor stores in the Calle del Desengaño, very close to Goya's home, you could buy the *Caprichos* for 320 reales in February 1799. An edition contained 80 large-format prints, numbered and with captions. The title *Caprichos* means whims – astonishing, fantastical ideas. Tiepolo and Giovanni Battista Piranesi had already created a series of such *capricci*. Under this title artists could permit themselves creative freedom, escaping the conventional themes and rules of art. Sense and nonsense, gravity and satire were all possible. Goya took out an advertisement in a Madrid newspaper and announced that in the *Caprichos* he was depicting human folly, prejudice,

They carried her away!
Capricho No. 8
1797–1798
Etching and aquatint
21.7 x 15 cm

Two faceless men are assaulting a woman who is screaming in despair; the huddled figures give the impression more of a rape than a kidnapping. Set against a completely dark background, the scene suggests nameless horrors being carried out under the cloak of darkness.

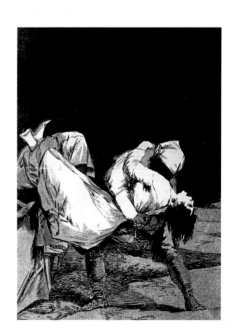

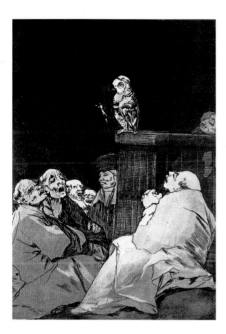

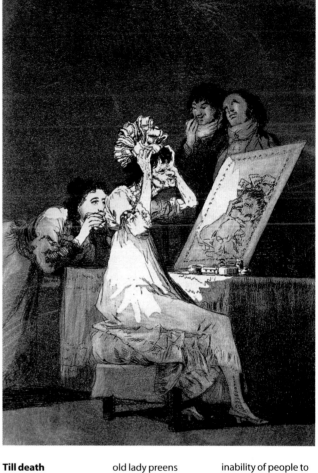

What a golden beak!
Capricho No. 53
1797–1798
Etching and aquatint
21.7 x 15.1 cm

With open mouths and closed eyes, the gathering of learned men listens attentively to a lecture from a parrot, which is gesticulating with its claw as if in learned disputation. Their spiritual inertia and their passive submission to authority prevent those listening from appreciating how ridiculous the speaker and his words are. A contemporary commentator was just as critical as Goya; writing of doctors he observed: "They can recite a complete list of diseases, but cannot heal them. They deceive the patients and stuff the cemeteries with skulls."
For Goya it was clear that Church and Inquisition were inhibiting progress in Spain. From their robes the figures in the foreground are clearly identifiable as monks. Goya often criticized the Church in his *Caprichos*, and generally attacked the mendacious double-dealing of monks and clerics.

Till death
Capricho No. 55
1797–1798
Etching and aquatint
21.8 x 16.2 cm

The *Caprichos* give a pitiless image of social and moral standards. No matter who they are, no one escapes criticism – dignitaries, doctors, lawyers, women, old people. Here a little old lady preens herself vainly in front of the mirror and does not notice how ugly she is, nor the laughter of those present. This could be regarded as a swipe at the queen, Maria Luisa, and her affairs with young men. But Goya was aiming higher than this. One of the basic themes of his *Caprichos* is the inability of people to see beyond self-delusion and deceit. The glance into the mirror in this *Capricho* is clearly not a moment of self-awareness, but the continuation of an illusion.

The Sleep of Reason Produces Monsters

The ugly, ambiguous winged beast
The vexatious companion of the night
Is swarming out and fluttering
About my head.

Johann Wolfgang von Goethe, *Tasso*, 1790

Reason and nightmare

The most famous print of the *Caprichos* series is No. 43 (opposite). While working, the artist has fallen asleep. Charcoal drawing sticks and unfinished drawings are lying on the table and he has buried his head in his arms. Fluttering towards him from the dark background the flying creatures of the night are harrying him, their staring eyes wide open. An owl has already taken hold of his drawing materials. A nightmare, realistic and yet unreal. We see both the sleeping form and what he is dreaming. The title is written in pale letters on the table, *El sueño de la razon produce monstruos*: "the sleep of reason produces monsters." As soon as the artist sleeps, and his fantasy is no longer controlled by reason, he finds that he is exposed to horrifying beings that threaten to overcome him. In the *Caprichos*, both forces are at work: clear reason and a dark, uncontrolled fantasy. Goya found the inspiration for this motif in an exchange with friends, who were closely involved with the ideas of the Enlightenment. For them, reason was the central concept: the power of reason would reveal social injustice, banish superstition, and subdue destructive passions.

The emergence of the theme

Originally, Goya had planned a series entitled *Sueños* (dreams). A sheet showing a dreaming author was intended as the title page. He conceived these prints as a series of satirical images inspired by *Sueños*, short prose pieces by the Spanish poet Francisco Gomez de Quevedo (1580–1645). However, Goya then decided to place the page with the dreaming artist among the other prints in the cycle, as print No. 43, where it forms the basis of a series of images of demons and witches. A study shows how Goya developed the dream apparitions from a jumble of sketches (left). There in the upper half of the drawing appears his self-portrait wreathed in beams of light, but surrounded by shadowy masks. Violent, dark hatching marks the region of night's winged shadows. In a second study, he added to the table an inscription clearly describing his intentions. It reads: "Ydioma universal", meaning a generally understood universal language. Beneath this is added: "The dreaming author. His sole intention is to banish destructive banalities and, through this

work of fantasy [caprichos], to lend permanence to the reliable testament of truth." Instead of this, the final version shows only the evocative final title of the print, Goya's most widely quoted words.

Goya's technique

Goya was one of the first artists in Spain to use a new technique from France, the so-called aquatint process, for the *Caprichos* series. This made it possible to print not just lines, as with the conventional form of etching, but also areas in finely granulated tone. It was only with this process that the impenetrable gray of the backgrounds and areas of shade were achieved which lend the *Caprichos* their strange effect.

Opposite:
The sleep of reason produces monsters
1797
Pen and sepia
19.5 x 12 cm
Madrid, Prado

Right:
The sleep of reason produces monsters
Capricho No. 43
1797
Etching and aquatint
21.5 x 15 cm

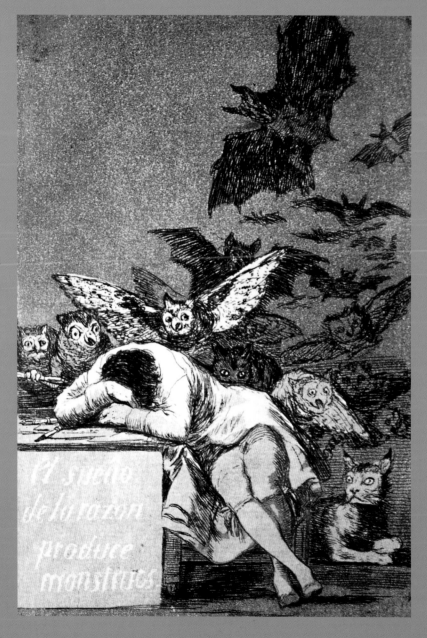

Goya's Demons

Goya's great contribution lies in the fact that he makes the monstrous believable. His monsters are credible, well-balanced creatures... All these contortions, these animal distortions and devilish grimaces are thoroughly human. One cannot reject them, even from the viewpoint of natural history... In a word, the line of suture, the boundary between the real and the fantastic is impossible to grasp ...

Charles Baudelaire

In the first part of the *Caprichos*, Goya uses the art of the caricature to criticize specific social evils, such as prostitution, the deceptions of love, and the corruption of monks and of the aristocracy. In the next part, however, the figures in the *Caprichos* assume positively demonic features, and the transition between man and monster becomes uncertain. The denizens of the night had occupied Goya's fantasy long before he gave them shape in the *Caprichos*. He first painted devilish grimaces in 1783, in the dark background to an altar painting for the Dukes of Osuna. There, they embodied the power of death and the Devil, and a saint drives them away with the help of God. Goya's idea for this motif was thus as an element of traditional religious imagery. The threateningly monstrous,

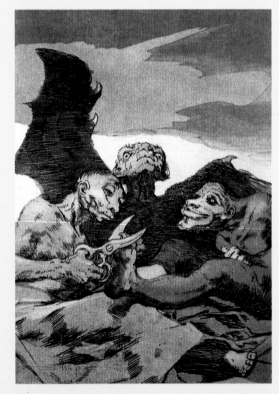

Left:
They're preening themselves again
Capricho No. 51
1797–1799
Etching and aquatint
21.4 x 15.1 cm

Right:
Hieronymus Bosch
Hell
Right panel of the triptych
The Garden of Earthly Delights
ca. 1503
Oil on wood
220 x 97 cm
Madrid, Prado

Where is mother going?
Capricho No. 65
1797–1798
Etching and aquatint
20.9 x 16.7 cm

which has occupied the minds of men since time immemorial, had its place in the world of Christian imagery as a representation of Hell. The most famous examples of this can be found in the paintings of the Netherlandish painter Hieronymus Bosch (1450–1516). His pictures, overflowing with demonic grotesques, found early appreciation in Spain.

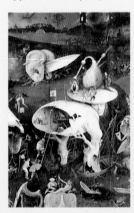

In Goya's day, over 30 paintings by "El Bosco," as the Spanish called Bosch, were to be found in the Spanish royal collections, among them the famous *Garden of Earthly Delights* (opposite, bottom right). The obscure symbolism of Bosch's vision of Hell, however, is still based on a Christian view of the world, where good and evil have their allotted place. In Goya's *Caprichos*, by contrast, there is no longer any positive force to counter the dark and the monstrous. In print after print we have new horrors bearing down on us, gathering for inexplicable rituals, rising into the air in combat, or simply cutting their huge claws (opposite, bottom left). Goya's imagery resists any unambiguous interpretation, though it is clear that anticlerical and sexual references are hidden in many of the prints. Goya's Enlightenment contemporaries shared his morbid fascination for the demonic world. His close friend, the author Leandro Fernández Morátin, took an interest in the subject and gave Goya a great deal of inspiration. Even in the circles of the cultured aristocracy, who, unlike the uneducated populace, no longer believed in witches, the thrill of ghost stories remained as keen as ever. Goya painted a series of witch pictures for the Duchess of Osuna's Alameda country seat, which was itself called "El Capricho." The painting entitled *The Devil's Lamp* (right) refers

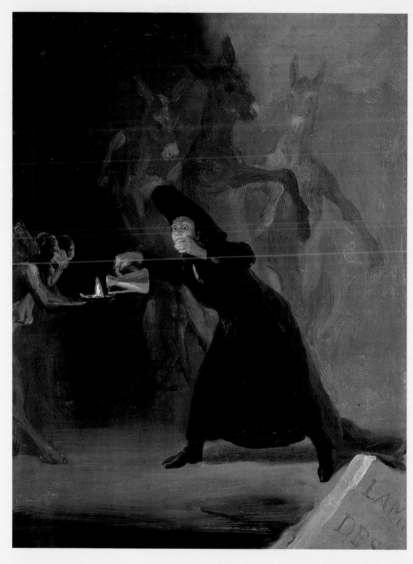

directly to a satirical play. The scene takes on a comic tone when it is realized that the principal character is not really bewitched, merely persuaded that he is by others.

In the *Caprichos* and in the late "Black Paintings," on the other hand, a nightmare reality is created from the macabre humor. In these pictures, Goya shows that the irrational, the demonic, and the monstrous reside in humanity itself.

The Devil's Lamp
1797–1798
Oil on canvas
42 x 30 cm
London, National Gallery

The Height of Fame

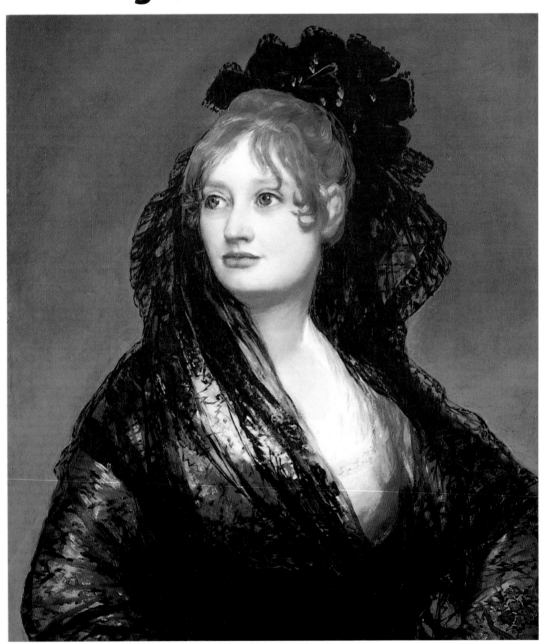

Goya's appointment as First Court Painter in 1799 was the apogee of a long and slow rise that had begun 25 years previously with his post as tapestry designer. Clearly, his *Caprichos*, despite their social criticism, had not damaged his reputation at court, for in 1800 he received a prestigious commission to paint a life-size portrait of the royal family. As no artist before him, he was brave enough to portray the members of the ruling dynasty in all their banality and ugliness – so realistically that even today we have to see his portrayal of the royal family as an act of sheer audacity. What is all the more amazing is that royal patrons gave it their enthusiastic approval. Goya's ability to portray the unique features of an individual through the medium of paint was now reaching its peak, and for several years he dedicated himself almost exclusively to portrait painting. He also used the wedding of his son Javier as a reason for painting the members of his own family, and for the first time.

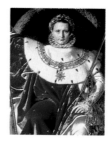

Emperor Napoleon Bonaparte, 1806

Self-caricature by Goya, 1800

1799–1802 Second Austrian War between England and several other European states against France.

1800 Child labor is prohibited in many English factories.

1804 Napoleon I has himself crowned Emperor of France; the **Code Civil**, the basis for democratic legislation, is introduced. Death of Emmanuel Kant.

1799 Goya appointed First Court Painter. He paints portraits of the queen and of the king, as well as equestrian portraits of them both.

1800 *Portrait of the Countess of Chinchón*, after which Goya worked on sketches for his portrait of *The Family of Charles IV*, which he executed on a large canvas from July onwards. Goya buys a house in Madrid.

1801 In July, the royal family portrait is completed. Manuel Godoy becomes commander in chief of the Spanish armies: *Portrait of Manuel Godoy*.

1802 Goya mainly paints portraits of the aristocracy and middle classes.

1803 Acquires a second house in Madrid.

1805 Marriage of Goya's son Javier.

1806 Birth of Goya's grandson Mariano.

Opposite:
Portrait of Doña Isabel de Porcel (detail)
1804–1805
Oil on canvas
82 x 54 cm
London, National Gallery

Right:
Portrait of Javier Goya (detail)
1805–1806
Oil on canvas
Diameter 8.1 cm
Paris, private collection

Goya as First Court Painter

Goya had climbed up the official ladder step by step during his career: 1780, member of the Academy; 1786, painter to the king; 1789, Court Painter; and now, in 1799, he was at last *Primer Pintor de Cámara*, First Court Painter. As First Court Painter he had an annual income of 50,000 reales, and a supplement to maintain a coach. For every portrait and every sketch he painted for the king, he was paid extra. Goya, who was always very good at managing his finances, invested his money in property and shares. Nevertheless, he did not allow his artistic freedom and his uncompromisingly sharp gift of observation to be bought off.

His overall relationship with the monarchs was not free of contradictions. He observed the intrigues and affairs at court without illusion and did not hesitate to criticize these relationships in his *Caprichos*. Many aspects, such as the liaison of Queen Maria Luisa with Manuel Godoy, were open secrets. In the intrigue-ridden gossip of the court, Goya behaved with tact and loyalty. He gladly responded to marks of favor and prestigious commissions. No one would have expected idealized state portraits from him – clearly no one did. His portraits depict the powerful realistically and unflatteringly. Yet his patrons found the naturalism of their official portraits to be anything but impudent; in fact they were

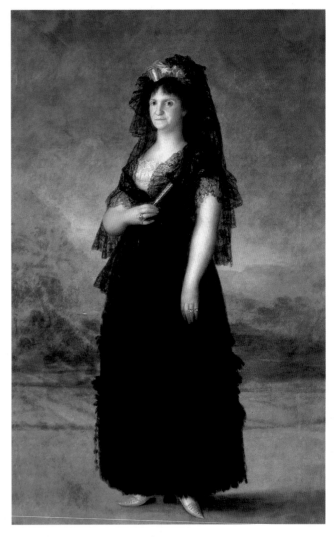

Portrait of Queen Maria Luisa
1799
Oil on canvas
210 x 130 cm
Madrid, Palacio Real

The queen, who was known for her vanity, is shown as a woman elegantly dressed, wearing a black lace mantilla, high comb, and fan. A dress like this, which cost thousands of reales, was the last word in fashion and would have been worn by the women of the higher aristocracy as well as (in simpler versions) by the prostitutes on the streets of Madrid. The similarity with the *Portrait of the Duchess of Alba* (page 41) is plain – a comparison that was to the queen's disadvantage.

usually delighted by the vivid likeness he had been able to capture.

On the tenth anniversary of the reign of Maria Luisa and Charles IV, Goya painted individual portraits of the monarchs which were so popular he was immediately commissioned to paint a large picture of the whole royal family. Even the powerful Godoy not only had himself and his wife painted by Goya, but also ordered paintings from him for his palace and ultimately gave him a controversial commission: to paint the *Nude Maja*, the first nude female in Spain since Velázquez' *Rokeby Venus* (page 63).

Portrait of the Countess of Chinchón
1800
Oil on canvas
216 x 144 cm
Madrid, Duque de Sueca

The portrait of the 21-year-old countess in her simple white dress is one of the most famous and sensitive portraits by Goya. The ears of corn in the countess' hair are an indication that she is pregnant. She had been married against her will to the powerful statesman Manuel Godoy, who had also remained the queen's favorite.

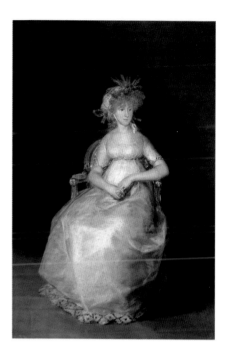

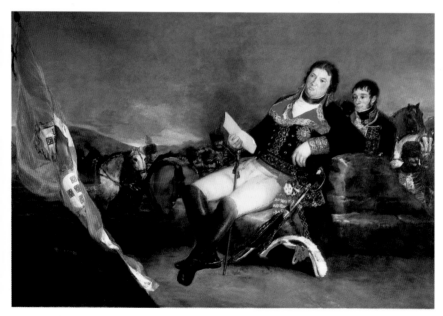

Portrait of Manuel Godoy
1801
Oil on canvas
180 x 267 cm
Madrid, Academia de San Fernando

Self-righteous, blasé, and slightly bloated is the impression we have of the most powerful man in Spain, in his field marshal's uniform. First the queen's equerry, later her lover, Godoy was hated by the people and known for his numerous affairs; even today he is one of the most disputed figures of his times.

Portrait of the Royal Family

The baker on the corner and his wife, after they won the lottery!

Théophile Gautier on Goya's *The Family of Charles IV*

Self-Portrait (detail from *The Family of Charles IV*)

Did Goya want to caricature the king and his family? To criticize them? To this day there are questions about the over three-meter (11-feet)-wide painting of *The Family of Charles IV*. In May 1800, Goya traveled out to the royal summer palace at Aranjuez to begin work on this major commission by painting several portrait studies. The queen would have preferred to have done without the boring sittings, but when she saw the oil sketches, she was thrilled. Goya first painted each member of the family individually, on canvas prepared in red. He only sketched the clothing, concentrating completely on the expressions and facial features. The studies of the six-year-old Infante Francisco de Paula are a wonderful example of animation in a portrait study. The older members of the family appear more distant, though they are by no means portrayed as excessively ugly. Goya represents them unassumingly – as people, not better looking, more reflective, or more important than anyone else. They do not have the dignified, regal authority that usually emanates from portraits of a royal house. Goya's attention to the sparkling medals, the splendor of the jewelry and the clothes clearly underlines this point. The composition of the family portrait was planned very precisely. The task was difficult enough: thirteen standing individuals, but grouped in such a manner that the composition produced a well-balanced but not dull arrangement. At the same time, it was necessary to depict the individual royal personages according to their rank. In the center, clearly lit, stands the 48-year-old queen in her sumptuous and fashionable Empire-style dress, holding her youngest children with maternal solicitude. Slightly in front of the queen stands the king. Counterbalancing him, the heir to the throne, Prince Ferdinand, stands to

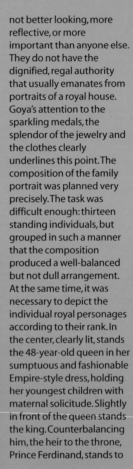

Diego Velázquez
Las Meninas
1656
Oil on canvas
318 x 276 cm
Madrid, Prado

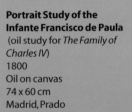

Portrait Study of the Infante Francisco de Paula
 (oil study for *The Family of Charles IV*)
1800
Oil on canvas
74 x 60 cm
Madrid, Prado

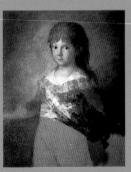

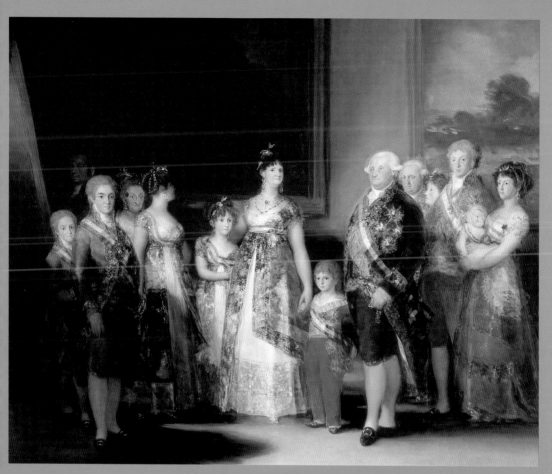

the left, in a blue coat. As his future bride had yet to be chosen, the young woman at his side, dressed exactly like the queen, is turning her face away, as if by chance. On the right-hand side of the painting, almost hidden behind the king, we see his brother, Don Antonio Pascual, and the Infanta Doña Carlotta Joaquina, and in front of them, the Prince of Parma and his young wife, her baby son in her arms. In the semi-darkness to the

left, we see the artist himself with his large canvas. His head is at the same level as those of the royal family – he is not representing himself as a subject and courtier here, but as an independent, sober observer and organizer of the event. At the same time, this is a reference to the foreground of Diego Velázquez' *Las Meninas*, where the painter places himself to the far left (opposite). This most famous of Spanish group paintings

shows the little Infanta Marguerita surrounded by her maids of honor in a room in the Alcázar fortress filled with paintings. As in Velázquez' painting, Goya's court group also seems to be looking at themselves in a mirror while the artist paints them.

The Family of Charles IV
1800–1801
Oil on canvas
280 x 336 cm
Madrid, Prado

Portraits and Scenes of Everyday Life

After Goya had completed *The Family of Charles IV*, he withdrew increasingly from court life. He probably thought it wiser to remove himself as far as possible from the sphere of the monarch, whose unpredictable politics had led to the fall of many of Goya's friends.

His artistic interests now lay mainly in portrait painting. He accepted a large number of portrait commissions and within a few years had painted 40 portraits, mainly of individuals from the affluent middle classes of Madrid. He himself had meanwhile joined this social group. His salary as First Court Painter,

Portrait of Bartolomé Sureda

1804–1806
Oil on canvas
119.7 x 79.4 cm
Washington, National Gallery

Bartolomé Sureda, the director of the Royal Porcelain Manufactory, was a well-traveled specialist in new printing and ceramic techniques. Self-confident, almost casual, he leans on a small table, his hat in his hand. His clothing – the tailored coat, the neck-cloth – and his hairstyle are typical of bourgeois fashion of the time.

Young Women on a Balcony

1805–1812
Oil on canvas
194.8 x 125.7 cm
New York, Metropolitan Museum of Modern Art.

Behind the balustrade sit two women in expensive lace mantillas, two majas, perhaps prostitutes. Behind them, in the shadow, stand their companions, with black capes and hats pulled over their faces. This gives the picture a slightly disturbing quality, as though the observer is also the observed.

together with the income from portrait paintings, meant he could afford an expensive lifestyle, and he acquired two houses in Madrid, one at 15 Calle de Valverde, where he lived with his family until 1819, and a second at 7 Calle de los Reyes. This he gave to his son Javier when he married in 1805, aged 24. In the following year, Javier and his young wife Gumersinda, who was expecting their first child, moved away from Goya's household.

Goya painted some of his finest portraits around this time. The men and women of the middle classes radiate a natural self-confidence. Apart from the name, we often know little about the individuals portrayed, but these images are nevertheless fascinating as character

studies, and the inner presence of the subjects is often enthralling.

Because of his deafness, the artist was largely reliant on the gestures of those he was communicating with; he could make himself understood in sign language only with a few of his closest friends and relatives. This undoubtedly contributed to his sensitivity as a portrait painter. Spanish portrait painting had long been characterized by a high degree of naturalism. Goya, however, combined a sharp-sighted perception with his freer, open technique of painting. This endowed his portraits with an unusual degree of animation – as though a smile had briefly flitted across a sitter's face a moment before, or she had just moved.

In addition to commissioned work, Goya was completing a large number of drawings. He filled countless albums with observations and ideas, as if keeping a secret diary. These drawings were not studies for paintings or prints, but works of art in their own right. During this period, Goya did not use a pencil: he generally worked with a paintbrush and used black or brown ink. He often added a few words as a commentary. Nothing fascinated him more than people and their behavior – their beauty, cruelty, despair, and pride.

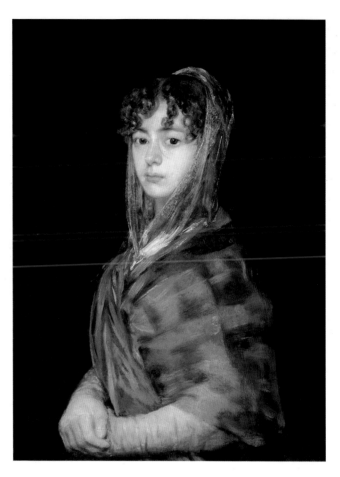

Portrait of Francisca Sabasa García
1804–1808
Oil on canvas
71 x 58 cm
Washington, National Gallery of Art

The direct gaze of this young woman seems at once open and yet rather distant. Her proud, upright posture gives the impression of natural dignity and elegance.

No external display, no colorful brilliance distracts us from her personality. Goya portrays the gentle facial features with a slightly soft focus, a device that enhances the animated effect of the portrait still further. Her clothing, painted with broad, sweeping brushstrokes, is sketched in freely.

The young woman is wearing a diaphanous lace scarf over her hair, with locks falling freely onto her brow. Around her shoulders she has a brown shawl with a pattern Goya has only hinted at.

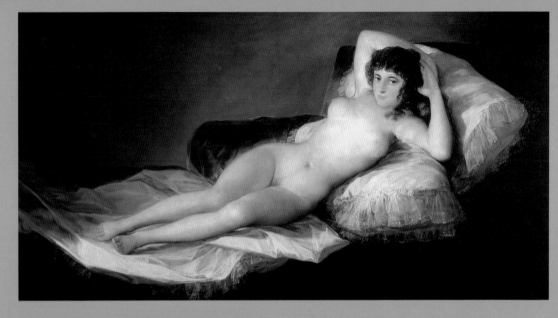

The *Clothed Maja* and the *Nude Maja*

A scandalous painting
Two paintings each show the same woman in exactly the same pose. With her hands clasped behind her head, she is stretched out on her upholstered couch and gazing directly at the observer. The clothed maja is already an erotic challenge. Her translucent fine silk gown emphasizes her physical form more than it hides her. The clothed maja challenges you to imagine her naked. Goya turns this game of fantasy upside down with his painting of the maja nude. Like a picture puzzle, the one merges into the other – it is very likely that the painting of the clothed maja was used to cover its nude companion piece, for this painting was a scandal. Depictions of the unclothed human form were strictly forbidden by the Spanish Church.

Goya and the traditional nude
Since the 16th century, the royal art collections had included the famous female nude by Titian. During the Italian Renaissance the nude had become one of the standard themes of art, but was always presented within a mythological framework – for example as a depiction of Venus, the goddess of love. The only nude in Spanish art had been executed by Velázquez 150 years before Goya. His Venus presents the classical

Titian
Venus with Organ Player and Cupid
ca. 1548
Oil on canvas
148 x 217 cm
Madrid, Prado

goddess as a very mortal beauty who, though she has her back to the observer, is looking back at him through the mirror. In this way, the observer sees her body in all its beauty, but sees her face only indistinctly (bottom right). By contrast, Goya's maja is almost brutally direct. All mythological embellishment falls away. The model offers herself to view in full consciousness of her charm and seems at the same time to observe the effect closely.

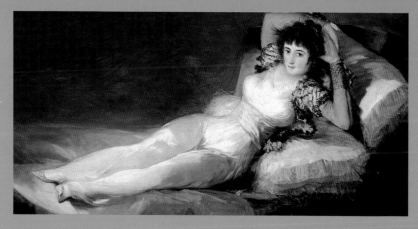

Model and patron

It was once wrongly assumed that the Duchess of Alba was the model for this painting, though there is in fact little similarity between the two women. Goya probably painted a maja from Madrid, a woman of the people, who was able to exploit her physical assets self-confidently and profitably. It was possibly even the very Pepita Tudo who became Godoy's mistress and whom he later married after becoming a widower. No one but Godoy, the most powerful man in the country, would dare to commission such a painting and to hang it in his palace. Only selected visitors were permitted to see the secret cabinet in which the *Nude Maja* was kept. The painting hung immediately beside Velázquez' Venus, a gift to Godoy from the Duchess of Alba at the time of their liaison. In 1808, after Godoy's fall, the daring painting was confiscated. In 1814 Goya had to answer for it to the

Inquisition; unfortunately, we know nothing about the course of his trial.

The modernity of the *Majas*

The provocation in the woman's gaze can still be felt today. Writers, art historians, and artists have been fascinated, irritated, or offended by it. The Czech painter and author Karel Capek (1890–1938) summarized the essence of the revolutionary content of this painting: "The end of erotic deception. The end of allegorical nudity. She is Goya's single life painting, but she discloses more than mountains of academic flesh could ever do." Painters of the modern movement picked up the tradition of Goya's painting of the naked maja: Edouard Manet in his

painting of *Olympia*, a Paris prostitute, Picasso with his reclining nudes.

Clothed Maja
1798–1805
Oil on canvas
95 x 190 cm
Madrid, Prado

Opposite:
Nude Maja
1798–1805
Oil on canvas
97 x 190 cm
Madrid, Prado

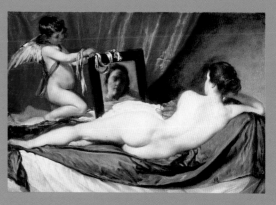

Diego Velázquez
Rokeby Venus
ca. 1650
Oil on canvas
122.5 x 177 cm
London, National Gallery

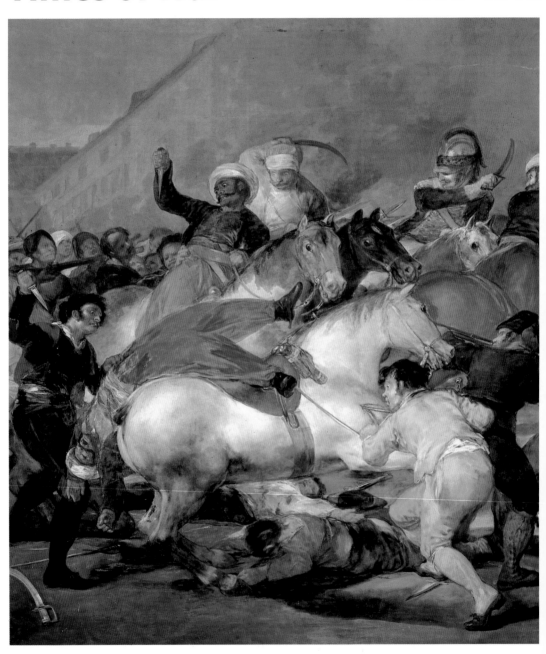

In 1808, war interrupted the even tenor of Goya's successful career. Napoleon's troops, on their seemingly unstoppable advance in Europe, suddenly appeared in Madrid, too. The Spanish king was deposed. For five years the Spanish people's struggle for freedom raged against the French occupier, a struggle that was fought with great harshness on both sides. The fighting stopped only after the intervention of English troops under the Duke of Wellington. Yet the new king, Ferdinand VII, did not bring the longed-for freedom, but ruled despotically. During this troubled period Goya became a passionate Spanish patriot – but he was also a supporter of the French Enlightenment. Despite these contradictions, in his professional life he tried to reach an understanding with the changing regimes. Secretly, he was working on prints that represented the brutality of war more savagely than any paintings or drawings had ever done before. His paintings of the Spanish uprising express an angry protest against war and brutality that transcends the war in Spain.

Caspar David Friedrich: *Voyager Above a Sea of Clouds*

Goya in 1815

1808 Uprising of the Spanish people against the despotic regime of Godoy. Start of the excavations at Pompeii in Italy.

1808–1809 Napoleonic troops occupy Madrid and take Saragossa.

1814 Napoleon abdicates and is exiled to Elba. Congress of Vienna. Ferdinand VII becomes King of Spain.

1818 The German romantic painter C.D. Friedrich paints *Voyager Above a Sea of Clouds*.

1808 Goya travels to Saragossa to sketch ruins.

1810 Begins to record the horrors of war in his etchings.

1811 Joseph Bonaparte awards him the Royal Order of Spain.

1812 Goya's wife Josefa dies. *Portrait of the Duke of Wellington.*

1813 Leocadia Weiss becomes Goya's companion.

1814 *The Third of May, 1808.* Goya has to justify his behavior under the French occupation. *Portrait of Ferdinand VII.*

1815 Start of a new series of etchings of bullfighting (*La Tauromaquia*).

1817 Journey to Andalusia.

Opposite:
The Second of May, 1808
1814
Oil on canvas
266 x 345 cm
Madrid, Prado

Right:
What courage!
1810–1815
Etching and aquatint
15.5 x 20.8 cm

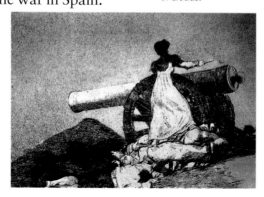

Casting Bullets in the Sierra
1810–1814
Oil on wood
33 x 52 cm
Madrid, Palacio Zarzuela

In the mountains by Saragossa, guerilla fighters secretly produced munitions during the war against the French, even though the possession of weapons was strictly prohibited. Goya had possibly seen such improvised munitions production in 1808, during his journey through the war-torn countryside.

Between Two Camps

When Napoleon needed to send his troops to Portugal, he had been granted support and a free passage through Spain by the statesman Manuel Godoy; what Godoy did not realize was that he was delivering his country into French hands. When the French troops marched into Spain in December 1807, the fate of Charles IV's reign was sealed. Napoleon put his brother, Joseph Bonaparte, on the throne. His liberal reforms meant that many intellectuals "collaborated" with the occupiers, but the majority of the Spanish people remained unswervingly loyal to the king.

Revolt broke out throughout the country, and a brutal guerilla war was waged. Everyone fought; even women threw themselves into the struggle.

Because she was a liberal?
1814–1824
Sepia and ink drawing, wash
20.5 x 14.2 cm
Madrid, Prado

The woman, chained at several points, has been imprisoned, as the inscription indicates, because of her political opinions. Goya here refers to the legalized atrocities under Ferdinand VII, who came to power in 1814. Opponents with liberal ideas were threatened with imprisonment and torture, which is why many of them went into exile.

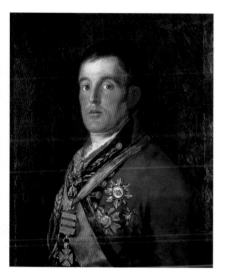

Portrait of the Duke of Wellington
1812
Oil on canvas
64.3 x 52.4 cm
London, National
Gallery

The Duke of
Wellington
commanded the
English troops in
Spain who, in 1813,
defeated Napoleon's
forces.

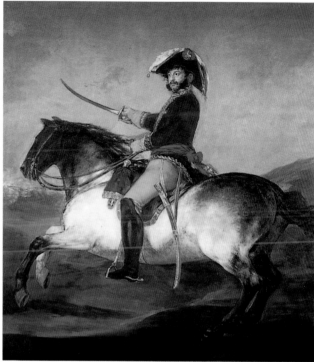

Portrait of General José Palafox
1814
Oil on canvas
248 x 224 cm
Madrid, Prado

General Palafox led
the resistance in
Goya's home town of
Saragossa. In October
1808 he challenged
the artist to paint a
picture of the
struggle against the
French and portray
the ruins of the
ravaged city.

Goya's behavior was contradictory during this turmoil. He had no hesitation in accepting commissions from Joseph Bonaparte; yet as a patriot he was on the side of the Spanish people. When the Napoleonic troops finally withdrew in 1814, Goya commemorated the outbreak of the resistance in May 1808 in two large paintings. These two pictures, *The Second of May, 1808* (page 64) and *The Third of May, 1808* (page 71), hung on a rapidly erected triumphal arch when the new Spanish king, Ferdinand VII, was welcomed jubilantly into Madrid.

Under the new regime, Goya had to answer for his behavior during the period of occupation, but was soon restored to his position as court painter. But no royal commissions came his way, however. The political circumstances were more oppressive than before, and liberals disappeared into the dungeons of the Inquisition and into the city prisons.

Goya withdrew from the court and followed his own objectives. He portrayed the nightmarish reality of the war and the disillusionment of the post-war years in a series of prints that were later given the title *Disasters of War*. They were not published in Goya's lifetime.

The *Disasters of War*

Hardly anyone saw these prints during Goya's lifetime. It was only to the art historian Bermúdez that he sent a complete copy with over 80 trial prints, so that his cultivated friend could correct the inscriptions. It was not until 1863 that the first edition of the series was published under the title *Desastres de la Guerra*, the *Disasters of War*. Goya had given them another title, *The Fatal Consequences of the Bloody War in Spain against Bonaparte and other Striking Caprices in 85 Impressions*.

Depicting the terrible reality of war stark and unvarnished, Goya showed how war turns men into beasts. He had seen it for himself, when he traveled across the country to Saragossa in 1808. He bought a large number of copper plates and began the etchings in 1810. Since copper was a rare commodity, he cut up some of his old engravings.

In addition to his own experiences, Goya used eyewitness accounts of the horrors committed. It had not been possible to ignore the events of the war, for there were no clear battle lines. Throughout the country underground fighters banded together to attack the French troops. Both sides, occupiers and occupied, butchered their enemies in acts of revenge, and civilians were seldom spared.

Goya's prints are by no means traditional depictions of battle. They

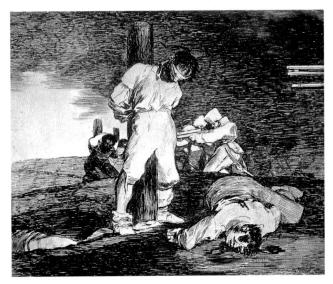

show summary shootings, rape, piles of corpses, horrifically mutilated people, hangings, people fleeing in panic, starving, wounded. The perpetrators became the victims and the victims became the perpetrators.

The discordant commentaries to the prints often stress the senselessness of violence, for example *Bury them and say nothing*, *This is not acceptable*, *No one could know why*, *It's no good screaming*, *Cartloads for the cemetery*. Finally, years after the war, Goya added a bitter satirical series against the state and the Church.

Only the final print in the *Disasters* expressed a timid hope: as light shines from truth, who has taken the form of a lovely woman, her enemies fade away, back into the darkness.

And no help came
Disasters of War No. 15
1810–1811
Etching
14.1 x 16.8 cm

French soldiers frequently executed rebellious peasants. Goya's composition is radical and decidedly modern, in that he renders visible the anonymity of the killing machine by showing only the barrels of the guns to the right. In the center of the picture stands the completely defenseless condemned man. Goya also adopted a similar composition for his famous *The Third of May, 1808* (page 71).

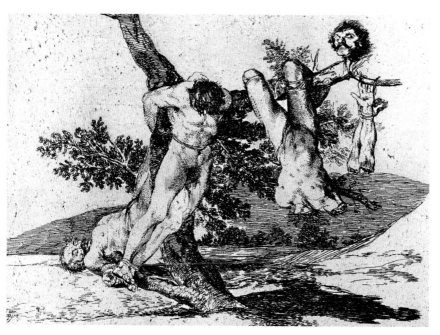

Great deeds! With corpses!

Disasters of War No. 39
1812–1814
Etching
15.7 x 20.7 cm

Hideously mauled, the corpses of three men have been left on the barren plain. Were these Frenchmen or Spaniards? Goya leaves the question open. He reaches back to the traditional image of the martyrdom of Christian saints, but here there is no hope of redemption in the afterlife. The suffering of these men is meaningless.

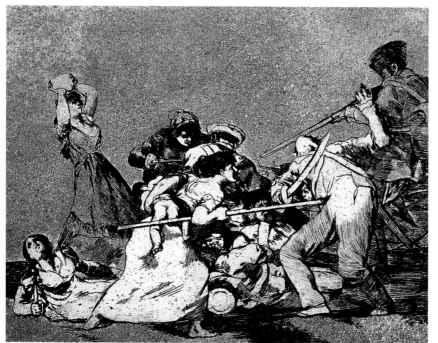

And they were as wild beasts

Disasters of War No. 5
1812–1814
Etching and aquatint
15.6 x 20.8 cm

The war swept away the distinction between civilians and soldiers, and between the roles of men and women. With the courage of their despair, their children in their arms, the women throw themselves upon their opponents. Contemporary sources do report wild attacks by women during battles and skirmishes. Goya dedicated several of the *Disasters of War* prints to them.

The Third of May, 1808

After the end of the war, Goya approached the government with the "burning desire to immortalize the most remarkable and most heroic deeds or scenes of our fabled uprising against the European tyrants." This was not least intended to demonstrate his loyalty to Spain. Goya started on two large-format paintings and selected as his subjects two key events from the beginning of the Spanish uprising against the French:

today's observer. Under the black night sky, French soldiers are carrying out the order to shoot at citizens taken from the streets of Madrid. In this act of revenge, any Spaniard caught carrying weapons was to be shot.

In some of his etchings from the *Disasters of War* series, Goya had already worked on similar compositions. In print No. 2 of the series, the two sides in the war stand opposed: the Spaniards fling themselves despairingly

The business of killing is carried out with cold precision. The dramatic lighting heightens the impact of the scene. The light from a large stable lamp falls coldly onto the victim who stands out from the others. The dead man is lying on the ground, arms outstretched, vividly indicating the fate that awaits the rebels behind him. The next victims of the execution are standing in the center of the painting. With arms stretched upwards, the central figure is reminiscent of the crucified Christ, and in fact it is possible to see wounds on the palms of his hands. With this reference, Goya transcends the contemporary framework and shows unequivocally that the horrific murder of defenseless people is a recurring reality. At the same time as this, great dignity is

conferred onto the condemned man.

The men are depicted in their hopeless situation with special psychological insight. The dramatic posture and gestures of the victims emerging from the darkness confront the observer directly. Nevertheless, Goya's layout places the observer on the same side as the murderers: we are almost looking over their shoulders.

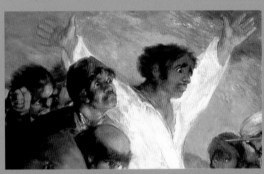

the revolt of the people of Madrid on May 2, 1808 (page 64); and the execution of the rebels the following morning. The first painting depicts the bloody battle between the rebels and the Mamelukes at the Puerta del Sol as a chaotic mélée in the tradition of Baroque battlefield paintings. The second painting, depicting the executions, has a much more modern feel for

with improvised weapons against the well-equipped French (bottom right). While we see the soldiers from the rear, Goya gives dignity and individuality to the rebels by depicting their faces. This principle of composition is further developed in the painting (opposite). Here, the faceless row of soldiers is pushed into a diagonal and the rifle barrels reach forward in parallel lines.

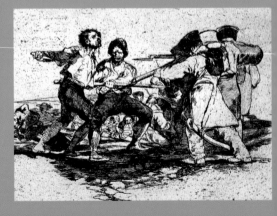

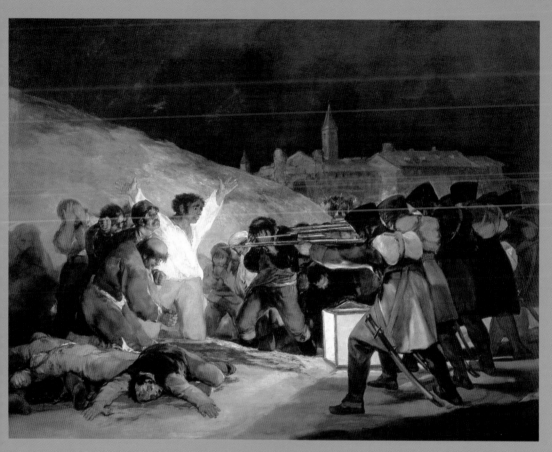

The Third of May, 1808
1814
Oil on canvas
266 x 345 cm
Madrid, Prado

Opposite left: Detail

Opposite:
Right or wrong
Disasters of War No. 2
1812–1815
Etching and aquatint
15.5 x 20.5 cm

Execution: Violence as Motif in Modern Art

Goya's modernity

Goya had no followers in his lifetime; in Spain, his painting remained a unique phenomenon. Even in the contemporary art of Europe, in the Classical and Romantic movements, there is hardly anything comparable. The effect Goya had on later generations was therefore all the stronger. His painting constantly inspired artists to use his compositions, adapt them, and take them further. The most famous example

of this is his painting *The Third of May, 1808*. Goya himself used well-known formulae from Christian painting for his work, from religious representations of violence such as the crucifixion of Christ and the killing of St. Sebastian with arrows. Yet something fundamentally new for art was happening in Goya's painting. His free painting technique, his critical, independent viewpoint, and the psychological depth with

which he portrayed human states of mind all make him an important precursor of the moderns.

Edouard Manet

The French painter Edouard Manet (1832–1883) saw Goya's painting *The Third of May, 1808* in 1865, in the Prado in Madrid. Two years later he was dealing with the theme of execution intensively in his own painting. The reason for this was a sensational event: during the struggle to free

Mexico from French domination, the Emperor of Mexico, Maximilian, who had been crowned by Napoleon III in 1867, was shot by republican forces. Manet created several versions of this theme, which he developed from an outline technique employing strong colors to a static composition in lighter tones. From Goya he adopted the confrontation between the executioners and their victims. But in doing this he heightened the situation by making the already short distance between them even shorter and by representing the precise moment of shooting, the flash and smoke of the discharge being clearly visible. For the soldiers, execution is apparently an everyday event: they are standing relaxed in a semi-circle, doing their duty; the officer is already re-loading his weapon. Only the onlookers, who are crowding up behind the wall, are aware that this is an extraordinary

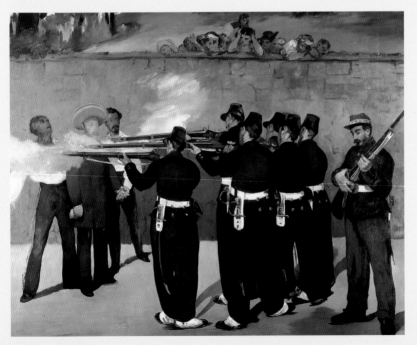

Edouard Manet
The Execution of Emperor Maximilian
1867
Oil on canvas
252 x 305 cm
Mannheim, Kunsthalle

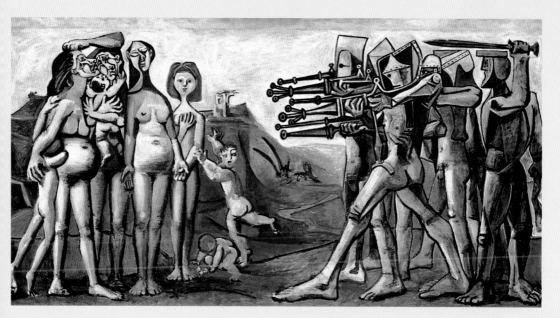

situation. Unlike Goya's dramatic painting, Manet's has the effect of a factual record of a historical event. The neutral gray tones and the bright daylight stress the sober atmosphere.

Pablo Picasso

Pablo Picasso (1881–1973), who knew both Goya's and Manet's execution paintings, gave a fresh twist to this theme. His picture was painted after World War II, when he was heavily committed to the international peace movement. Originally, Picasso planned the painting as a general symbol of man's inhumanity to man, and only while he was working on it did he give it a concrete reference to the massacre during the Korean War. Only the title gives any reference to an actual event;

the pictorial content itself is very general. Not only are the victims, women and children, completely naked, but so are the soldiers. However, the apparently natural nakedness is deceptive: the men appear robot-like, a dehumanized death machine. Brandishing strange weapons, they are completely gray, which alienates them even more. In its direct appeal for sympathy and indignation, the picture is almost overstated.

Wolf Vostell

The German artist Wolf Vostell, who often adopted a position of social criticism in his work, took up the theme of the execution in 1968, during the Vietnam War, in his painting *Miss America*. His source was the famous documentary photograph

of an execution in Vietnam taken by Edward T. Adams, which at the time was distributed worldwide by the media. Provocatively, Vostell contrasted the close-up shot of the execution with the picture of an American beauty queen, thus creating a juxtaposition of brutality and banality often found in modern media.

Pablo Picasso
Massacre in Korea
1951
Oil on plywood
109.5 x 209.5 cm
Paris, Musée Picasso

Wolf Vostell
Miss America
1968
Photograph, transparency and silkscreen print on canvas
200 x 120 cm
Cologne, Museum Ludwig

Goya and the Inquisition

The Inquisition had been called into being by the Church during the Middle Ages, to pursue heretics and to maintain the purity of Catholic belief. Over the centuries, the Inquisition, the so-called Holy Office, held sway in Spain and other parts of Europe. Even the slightest suspicion of heresy or sin could mean someone being delivered up to the Inquisition, particularly as believers had the duty of denunciation, under threat of the everlasting torments of Hell. Those accused of witchcraft were forced to "confess" through torture, and burning at the stake was the inescapable punishment. In Goya's time, the despotism of the Inquisition was already more subdued – the last time a witch was burned in Spain was in 1781. However, heretics and critics of the Church were still threatened with exile, disgrace, and confiscation of property. There was strict censorship, particularly of the literature of the Enlightenment – the translation, publication, and distribution of banned books and caricatures, even the possession of them, was strictly prohibited.

Goya went through the humiliating performance of an Inquisitorial trial several times. These autos-da-fé took place in public, in the presence of spiritual and lay dignitaries. No spokesman for the defense was permitted; the aim of these arbitrary courts was humiliation and a public admission of guilt from the accused. The latter had to wear the *sambenito*, the heretic's robe, and the *coroza*, a high, pointed penitent's hat.

Many thinkers of the Enlightenment were cited before this spiritual court, among them some of Goya's friends; they were not, however, arraigned before the court because it was decided – after Charles IV and Manuel Godoy used their influence to support them – that there was a "lack of evidence." In 1797, Goya himself was obliged to withdraw his *Caprichos* from sale because he feared the unwelcome attentions of the Inquisition. On one of the prints he had depicted the humiliation of an accused person in the typical robe of shame (opposite, top left). The seemingly ambiguous caption *This dust* is a reference to the trivial grounds for prosecution. Contemporary observers would be able to add to these words the rest of a well-known proverb, "From this dust, what a morass we have," which means

Execution of a Witch
1820–1824
Oil on wood
31 x 21 cm
Munich, Alte Pinakothek

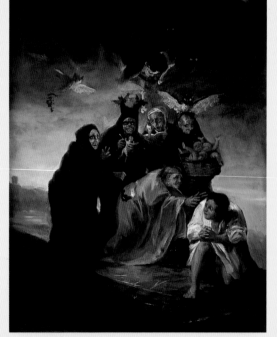

The Incantation
1797–1799
Oil on canvas
45 x 32 cm
Madrid, Museo Lázaro Galdiano

Opposite:
Judicial Session of the Inquisition
1812–1819
Oil on wood
46 x 73 cm
Madrid, Real Academia

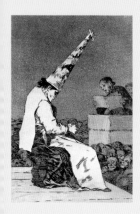

This dust
Capricho No. 23
1797–1798
Etching and aquatint
21.7 x 14.8 cm

something like "To make a mountain out of a molehill." During the French occupation, the religious court was abolished, but in 1814 it was reinstated under Ferdinand VII. Goya once more attracted the attention of the Inquisition when they came across his painting of the *Nude Maja*, which was considered to be offensive and a blatant infringement of the ban on the representation of naked people. It is not surprising, therefore, that at this time Goya painted several pictures on the themes of religious fanaticism and irrational behavior. A dark painting of a scene from the Inquisition shows the accused with pointed hats,

surrounded by a dense crowd of onlookers, in the half-light of a broad hall (below).

Another painting, named after a custom linked with Ash Wednesday, *The Burial of the Sardine*, depicts the uninhibited behavior of a group of masked people (right). The parade clearly refers to a religious procession. But Goya has transformed the event into a grotesque scene where delusion and reality are confused. Similarly, Goya's Inquisition scenes are seldom exact portrayals of real events; usually they are a reflection of his conviction that the Inquisition was the incarnation of spiritual oppression and despotism.

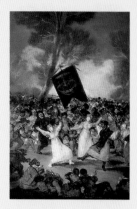

The Burial of the Sardine
1812–1819
Oil on wood
82.5 x 62 cm
Madrid, Real Academia

The "Black Paintings" 1819–1823

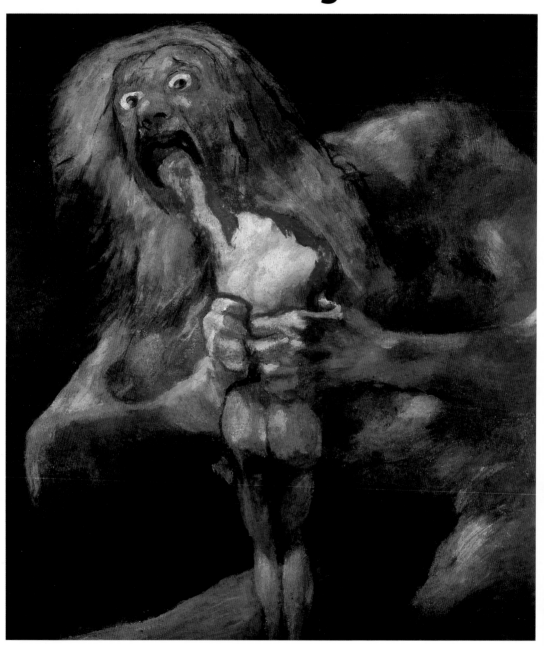

In 1819 Goya bought a small country house outside Madrid, where he could live with his young companion, Leocadia Weiss, far from the bustle and gossip of the city. In the same year he became so ill that he nearly died. After his recovery, he retired almost completely from public life and worked mainly for himself, thus freeing himself from having to take account of public expectations. In addition to the frescoes he painted in his house, known as "the House of the Deaf Man," he created a series of strange, absurd etchings. It was not until the Surrealists of the 20th century that artists were to draw so heavily on their own fantasies and dreams. Goya's images, however, are also a reflection of dramatic, radical political change. After the apparent victory of the supporters of reform in the uprising of 1820, the purges of the Inquisition and the secret police recommenced.

Ludwig van Beethoven, 1819

Man in disguise (Goya?), ca. 1823

1819 Spain sells its colony in Florida to the USA. The Prado opens as a museum of art. Beethoven composes his *Missa Solemnis*.

1821 Birth of the writers Charles Baudelaire, Feodor Dostoyevsky, and Gustave Flaubert.

1822 The Vatican accepts the Copernican (heliocentric) view of the universe.

1824 End of Spanish colonial rule in South America.

1819 Goya paints altarpieces. First attempts at the new technique of lithography. Severely ill towards the end of the year.

1820 The 73-year-old Goya survives the illness and paints *Self-Portrait with Doctor Arrieta*. During the course of this year, he paints large-format frescoes, the so-called "Black Paintings," in his house.

1821 Puts finishing touches to *Disasters of War* series of prints, in addition to work on the so-called *Disparates*.

1823 Goya gives his country house to his 17-year-old grandson Mariano. Leocadia Weiss, a liberal, goes into hiding because of increasing political persecution in Spain.

Opposite:
Saturn Devouring His Children
1820–1823
Oil on plaster, transferred to canvas
146 x 83 cm
Madrid, Prado

Right:
Goya's House (The House of the Deaf Man)
19th-century print

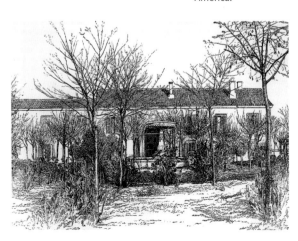

"The House of the Deaf Man"

The country house which Goya bought in 1819 for 60,000 reales lay outside Madrid, on the banks of the Manzanares, and was soon called Quinta del Sordo, "the House of the Deaf Man." Goya had reason enough, private and political, to flee city life. Under the disapproving eyes of his relatives, the young Leocadia Weiss had become his companion after the death of his wife. She was separated from her husband and made no secret of her liberal politics. She and her small daughter Rosario moved into the Quinta del Sordo with Goya.

In the two largest rooms of the house, Goya painted his last major series of pictures: 14 frescoes called the "Black Paintings" because of their predominantly dark colors and somber themes. They were painted in oils directly onto the walls. In the late 19th century they were detached from the walls and transferred to canvas. The Black Paintings belong to Goya's most enigmatic and oppressive works. One of the paintings shows an outlandish procession of pilgrims in a dark mountain landscape (page 31); and another, two men in a desolate landscape fighting with cudgels while sinking into quicksand. Then again, we make out figures hovering indistinctly in the air as in the painting *Vision (Asmodea)* (page 83). In these paintings dark forces, fanaticism, violence

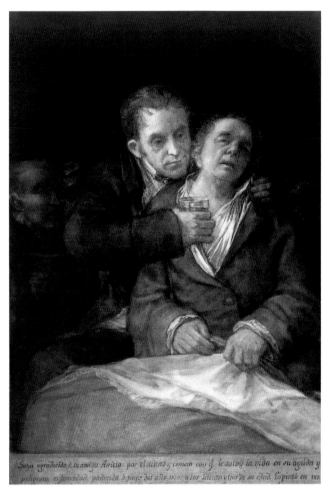

Self-Portrait with Doctor Arrieta
1820
Oil on canvas
117 x 79 cm
Minneapolis, The Institute of Arts

In the long dedication at the lower edge of the painting Goya records his thanks to the doctor who cared for him during his dangerous illness. The self-portrait shows the mortally ill painter helpless in the arms of the solicitous doctor, who is in the act of giving him medicine. It is only on second glance that we notice the outlines of faces in the background; they seem harbingers of the somber visions Goya painted on the walls of his house after his recovery. The color is so thin in places that the canvas is visible.

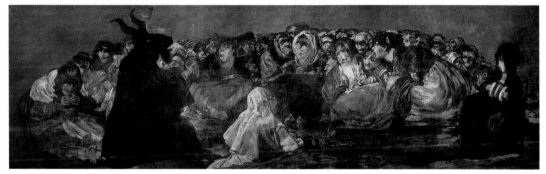

and fear hold sway. These oppressive visions give a vivid impression of Goya's fears and reveal him to be a lonely, deaf old man who had withdrawn into a deeply depressive and critical view of life. The Spanish author Ortega y Gasset (1883–1955) wrote of Goya's work: "Is what we see good or bad? Does it mean what we think it does, or exactly the opposite? Is its effect an expression of the artist's wish, or does what he paints come into existence independently of his will? In a word, is he a highly significant genius or a madman?" In many of the Black Paintings Goya adopted mythological or biblical scenes which, as with his subjective visions, he represented as oppressive nightmares, as with *Saturn Devouring His Children* (page 76). Another painting shows the biblical figure of Judith slaying Holofernes.

One single painting radiates peace and possible reconciliation: the painting of Leocadia Weiss (right).

The Great Goat
1820–1823
Oil on plaster,
transferred to canvas
140 x 438 cm
Madrid, Prado

Well over four meters (about 14.4 feet) wide, this painting was also given the title *Witches' Sabbath*. It was painted in Goya's large living room, immediately next to the portrait of Leocadia (below). Perhaps she is also depicted in this painting: to the far right a young woman is sitting a little to one side of the gathering of witch-like creatures. She is looking distantly at the crowd swarming around the great goat. Since at least the Middle Ages the goat has been a symbol of the Devil and of lust; here its figure is seen as a black silhouette, its head emerging from the wide drapes that cover its body.

Goya, who did not paint this ghostly vision for public eyes, worked with broad brushstrokes, in tones of black, gray, and brown, with here and there a gleam of white shining from the eyes of the figures. Every object seems to merge together and blend with the somber background into indistinct clusters.

Leocadia
1820–1823
Oil on plaster,
transferred to canvas
143 x 132 cm
Madrid, Prado

Goya's companion looks thoughtfully from the painting. The theme of death is perhaps still occupying the painter here, as Leocadia is leaning on a rock that could also be a burial mound; above her is an open blue sky.

Sense and Nonsense

The last of Goya's series of prints is also the most enigmatic. He probably worked on them over a fairly long period, completing them about 1824. The prints were known under the title *Disparates*, which, loosely translated, means examples of nonsense, absurdities; a lot of the inscriptions to the pictures include the word *disparate*. Goya never published them, though they were undoubtedly designed with an eye to publication. When the first edition was printed from the plates in 1864, the series was given the title *Los Proverbios* (Proverbs), though no unequivocal equivalent of a proverb was ever identified.

The prints contain more or less absurd, Surrealistic images: bulls flying through the air, an elephant staring motionless at a group of men, people crouching like frozen birds on a branch, a horse catapulting a woman into the air, distorted faces screaming silently, and people fleeing from phantoms. Like the *Caprichos*, the *Disparates* could be described as a series of dreams. For, just like nocturnal dreams, they are both strange and familiar. Whoever tries to decipher them is groping in the dark. This enigmatic quality is precisely what endows the series with modernity. These subjects are no longer drawn from the traditional language of artistic images, but from a private world.

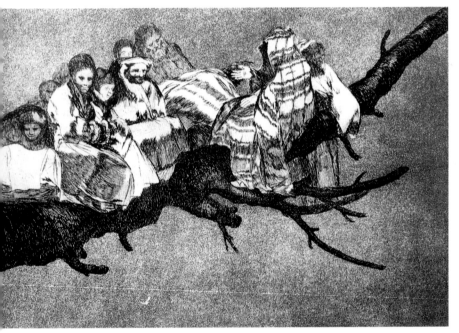

Ridiculous folly
1815–1824
Etching and aquatint
24.5 x 35 cm

Wrapped in blankets, people perch on a dead branch. Anyone who moves will fall into the bottomless depths below. In spite of their absurdity, the scene has a realistic effect. There is no firm indication of whether Goya intended a political meaning. These could be refugees, or people who have lost all contact with their environment. Others see here a symbol of the immobility of the antiquated social structures of Spain. Or, quite generally, a symbol of people alienated by the modern world.

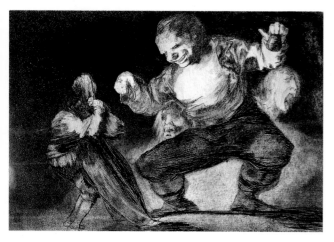

In many pictures political references can be surmised, but they are so deeply encoded that nowadays they can no longer be clearly deciphered. To some extent the images reveal human passions, superstition, and blindness. Many images seem no more than the whim of the moment. On some prints, Goya revisits motifs from his earlier works and stretches them to the point of absurdity. So, from the tapestry designs, we have the motif of the dancer or of the women playing with a man-sized straw doll (page 29). But the charming images of the young Goya have become coarse caricatures. The *Disparates* are not exactly amusing prints: the laughter at these absurd images is hollow and accompanied by a slight shiver of horror. The dark, empty background of the *Disparates* reinforces the observer's question regarding their meaning.

Disparate de bobo
(Blockhead folly)
1815–1824
Etching and aquatint
24.5 x 35 cm

With a broad grimace, the clumsy blockhead, a traditional Spanish clown, is parading about and playing the castanets as though taking a demonic pleasure in terrifying the other figure. The latter is taking refuge behind the figure of a woman who turns out to be a life-size figure of the Virgin Mary. Goya's criticism of the Church becomes even clearer in a study for this print, where a monk is hiding behind the figure of the Madonna. Goya sets religious belief and superstition face to face: they are nothing more than phantoms.

Tío Paquete
1820–1823
Oil on canvas
39 x 31 cm
Madrid, Museo
Thyssen-Bornemisza

This image is said to be the portrait of a well-known beggar who always sat in front of a church in Madrid and sang to the guitar. With his sardonic, featureless laugh the painting matches the dark humor of the *Disparates*.

Goya's Flying Creatures

There are heads which are so full of highly explosive gas that they require neither a balloon nor a witch to fly.

Goya

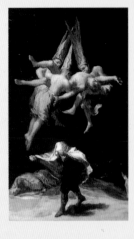

Bats, owls, witches, with and without brooms, even flying dogs, bulls and strange hybrid beings – such creatures populate Goya's pictures. The whole range of his imaginary world, of both his dreams and nightmares, is bound up in his representation of flight. At the same time as this, the motif of flight reflects the contradictions of his day, the age of reason. Science was constantly making new discoveries; electricity, magnetism, meteorology, and gravity were being researched. The conquest of gravity represented the crowning triumph of reason. This scientific aspect of flying fascinated Goya, and not only did he portray the first balloon flight in several ways (page 47), he also occupied himself with the idea of independent flight by man. Like Leonardo da Vinci, who also drew designs for fantastical flying devices, Goya drew people with bird-like wings, as in his print *A way to fly*, in which strange human kites soar through the air (opposite, top). Yet the more man came to believe that he could explain the world through reason, the more Goya distrusted the principle of pure reason. During the course of his life, he came to recognize increasingly that the dark reverse side of reason still existed, that the power of the irrational, the energy of unbridled passions, the power of aggression and fear, were still omnipresent dangers. From time immemorial heaven had been the sphere of the divine, an ethereal region reserved for gods and angels. Goya was well acquainted with the traditional images of heavenly beings; he knew the world of Christian imagery as well as the mythological heaven of the classical gods. Yet for him, flying was, above all, an embodiment of the demonic; and here images

Flying Witches
1797–1798
Oil on canvas
43.5x30.5 cm
Madrid, Prado

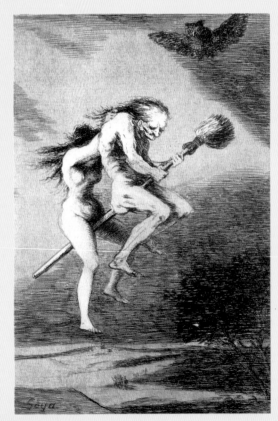

Left:
A fine teacher!
Capricho No. 68
1797–1798
Etching and aquatint
21.5 x 15 cm

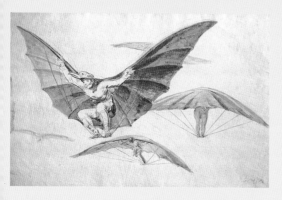

A way to fly
1815–1824
Red crayon on paper, with wash
24.5 x 35 cm
Madrid, Museo Lázaro Galdiano

Vision (Asmodea)
ca. 1820–1822
Oil on plaster, transferred to canvas
123 x 266 cm
Madrid, Prado

of ancient magic practices, in which people and witches fly through the air, played a key role in his imagination. With a few strokes, Goya was able to achieve the illusion of flight in his images, and to convince the viewer that figures are truly flying. Often the symbolism of flying suggests erotic connotations, too, for floating and a weightless levitation are familiar images of sexual pleasure. This interpretation also plays its role in the well-known motif of witches riding their broomsticks. Similarly, the subtitle of one of his Black Paintings, *Asmodea*, refers to an oriental demon of sexual desire. Nevertheless, here the relationship between image and title remains unclear. On a broad landscape background, two closely linked figures are rushing through the air without wings. One of the figures is looking back, as though they were being pursued, while the other figure is pointing to an enormous rocky outcrop in the background. In the distance a group of horsemen are on their way to an unknown destination; on the right, two riflemen take aim – are they aiming at the two airborne figures or at the riders? The subjective world of Goya's image is beyond interpretation. The fantastical scene depicted by this painting, a work executed without a commission, points toward the world of the 20th century; in Surrealism, too, for instance with Salvador Dali or Max Ernst, a personal language of symbols, set in unreal locations, plays a major role.

Exile in France

At the age of 77 Goya decided to leave his home. The reason was the political situation in Spain under the despotic rule of Ferdinand VII. Although Goya was still the official First Court Painter, his position was compromised. His prints alone, which he stored in his house, would have been incriminating, since even the possession of documents or caricatures that were deemed heretical or critical of the government was a punishable offense. His companion Leocadia was even more seriously threatened because of her known liberal views. They agreed to go into exile in France. Thus Bordeaux became the final stage in Goya's life. The grizzled, stone-deaf painter maintained an astonishing degree of activity till the end. Driven by simple curiosity, he traveled alone to Paris. He experimented with new artistic techniques and created images that were far in advance of the art of his times. His creative powers were undiminished right up to his death.

Lord Byron

Goya at the age of 78

1824 National Gallery in London founded. The English poet Lord Byron dies in Greece.

1825 Manufacture of the sulfur match.

1826 The last death sentence for heresy is carried out in Spain. The French physicist Niepce produces the first heliograph, a direct precursor of photography.

1828 A young man of unknown origin, Kaspar Hauser, appears in Nuremberg. Thought to be of noble birth, he becomes an international celebrity.

1824 Goya obtains leave to take the cure in France, and leaves in June. After a stay of two months in Paris he settles in Bordeaux with Leocadia.

1825 Paints miniatures on ivory and works on lithographs of bull-fighting scenes. He becomes critically ill.

1826 Journey to Madrid to obtain a royal pension; receives permission to return to France. Portraits of friends.

1827 Summer: last journey to Madrid. *The Milkmaid of Bordeaux.*

1828 Goya's grandson Mariano arrives in Bordeaux. Goya dies on April 16.

Opposite:
The Milkmaid of Bordeaux
1825–1827
Oil on canvas
74 x 68 cm
Madrid, Prado

Right:
This is how they circulate in Bordeaux
1824–1828
Black chalk on paper
18.4 x 14.2 cm
Paris, private collection

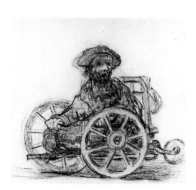

From Madrid to Bordeaux

Goya made preparations for his exile. His house, the House of the Deaf Man, was transferred to his 17-year-old grandson Mariano so that it could not be confiscated. Then he hid himself for three months with a friendly priest and waited for a favorable moment to submit to the king a petition to leave the country; his pretext was that he wanted to take the cure for his poor health at the spa in Plombières in France. Permission was granted. He had to use this ruse in order to secure not only a leave of absence, but also his annual salary of 50,000 reales. He left immediately and, after an arduous journey of 900 kilometers

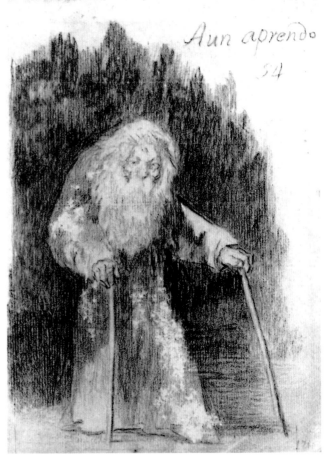

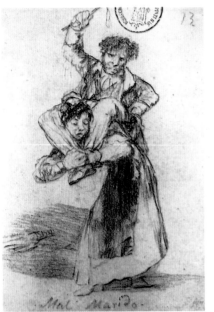

A bad husband
1824–1828
Charcoal on paper
18.5 x 13.5 cm
Madrid, Prado

Sitting on his wife's shoulders and using a whip, a man beats her as he would a beast of burden. Goya often dealt with relationships between the sexes in his satirical drawings. As with other themes,

he adopted a highly critical viewpoint. In the last years of his life, he often used black chalk for his drawings and frequently added a few words of commentary.

I am still learning
1824–1828
Charcoal on paper
18.7 x 13.5 cm
Madrid, Prado

This drawing of a fragile old man seems to be a symbol of Goya's own attitude in old age. In spite of his infirmity, he never lost his curiosity about life.

Vicente López
Portrait of Francisco de Goya
1824–1828
Oil on canvas
93 x 75 cm
Madrid, Prado

An artist with a precise style, and a pupil of Mengs, López was a sought-after court painter under Ferdinand VII. He executed this imposing portrait of Goya while the latter was in Madrid. Among the many self-portraits of Goya there is none that reproduces his external appearance so exactly; and none, either, that shows him in such a proud pose, as the successful artist.

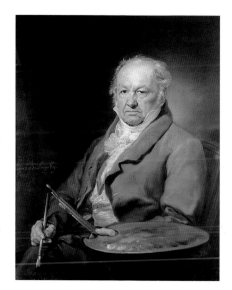

Portrait of Juan Bautista, Count of Muguiro
1827
Oil on canvas
102 x 85 cm
Madrid, Prado

This painting is one of the last portraits by Goya and shows a distant relative he had met in Bordeaux. A fairly lengthy inscription indicates that Goya painted this portrait at the age of 81.

(560 miles), he arrived at the home in Bordeaux of his old friend Leandro Fernández Moratín, who had already been living in exile for some time. The latter reported in a letter that "Goya has actually arrived, deaf, old, clumsy and weak, and without speaking a word of French. He has come with no servants … but is so eager to get to know everyone."

Hardly had Goya recovered from the exhausting trip when he went on to Paris. He stayed there for two months and lived with relatives in a smart, lively quarter of the city. From police reports – all Spanish emigrants were watched by undercover agents – we know that he mainly spent his time on tourist visits and going for walks. Anything that particularly interested him, he sketched in his sketchbook, adding the words "I saw this myself." It is possible that he also visited the current special exhibition at the Louvre, which included works by his younger contemporaries Jean-August-Dominique Ingres (1780–1867) and Eugène Delacroix (1798–1863).

Back in Bordeaux, Goya met his companion Leocadia and her little daughter Rosario. Together, they moved into a furnished flat in the Allée de Tourny. But soon he was drawn back to Spain. Moratín was surprised at his friend's energy. "If you permitted it, he would travel back on a stubborn mule with his beret, his coat, his stirrups, his bottle of wine and his rucksack." In fact, Goya traveled twice more to Madrid in the following year, not least to make sure that his pension would be paid to him.

The Bullfights

Bullfighting is the only art where the artist is in danger of his life and in which the degree of brilliance in the execution depends on his sense of honor.

Ernest Hemingway, *Death in the Afternoon*

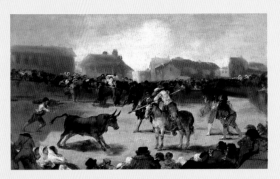

Village Bullfight
1812–1819
Oil on wood
45 x 72 cm
Madrid, Museo de la Real
Academia de Bellas Artes

Below:
The courage and agility of Juanito Apiñani
Tauromaquia No. 20
1815–1816
Etching and aquatint
24.5 x 35.5 cm

Like many of his contemporary fellow-Spaniards, Goya was, throughout his life, an *aficionado*, a keen follower of bullfighting. According to his own testimony, he was even daring enough in his youth to try his skill and courage against a young bull. During the second half of the 18th century bullfighting was more popular than ever, before it was prohibited in 1805. In Saragossa, and later even in the Madrid ring and in Seville in Andalusia, Goya attended some of the most famous bullfights of his day.

As a motif in his art, bullfighting occurs throughout his work, beginning with his tapestry designs and continuing right up to his last paintings, executed in exile in France. He often selected scenes from bullfights as a motif when he painted pictures without a commission. The small painting *Village Bullfight*, for example, shows an improvised corrida, as in the Spanish countryside (top left). The spectators have gathered in a broad circle in the village square and are watching as the mounted torero and the bull face each other.

Immediately after the war of liberation against the French, Goya worked intensively on the subject of bullfighting and created a series of 33 etchings under the title *La Tauromaquia* (The Art of Bullfighting). At that time in Spain, the motif of the bullfight had become a symbol of the struggle against the Napoleonic troops; in popular prints the bull stood for the French, while the courageous torero represented the people of Spain.

Initially, Goya's graphics were based on a history of Spanish bullfighting written by the father of his friend Moratín. During the work, however, he left the historic framework behind and selected the subjects arbitrarily. He remembered the legendary bullfights of his youth and depicted the most dramatic moments of the corrida. In these prints Goya demonstrated an

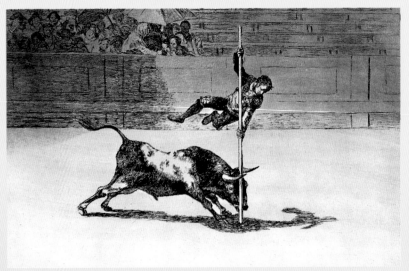

An unfortunate occurrence among the spectators at the Madrid Ring
1815–1816
Etching and aquatint
24.5 x 35.5 cm

extensive knowledge of the sport. He manipulates his etching tools with the same precision and skill as the picadors and toreadors use in wielding their lances and swords. Light and shade are distributed in a masterly fashion, and print after print

reveals new compositions full of tension. Goya boldly juxtaposes full and empty spaces, as for example in the print *An unfortunate occurrence among the spectators at the Madrid Ring*.

In exile, almost 80 years of age, Goya returned once more in 1825 to this old passion, and exploited the newly invented technique of lithography for a small series entitled *The Bulls of Bordeaux*. In prints such as *The Famous American Mariano Ceballos* (top right), he mainly reproduced the atmosphere in the bullfighting arena, the spellbound fascination of the spectators, the air tense with excitement. As though

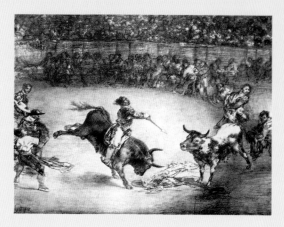

drawn by magic, the spectators press through the barriers and move closer and closer to the blood-soaked spectacle. At about the same time, Goya painted a few small pictures on

The Famous American Mariano Ceballos
1825
Lithography
30.5 x 40 cm

bullfighting themes. The drama of the event was expressed in these with impasto color and a complete lack of detail. The churned-up colors, the shimmering reflections of light, the mobile shadows – everything contributes to the impression of dynamic movement.

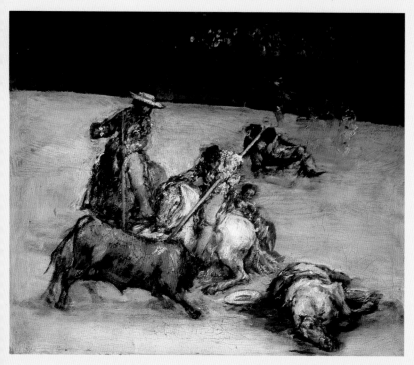

Corrida
1824–1825
Oil on canvas
32 x 44 cm
Madrid, Prado

Last Images

Goya worked at his art until the very end. He enjoyed his peace and independence in Bordeaux. He occupied himself with new artistic techniques with continuing pleasure in his discoveries. In Paris he was able to extend his knowledge of the art of lithography and was now working on several litho-graphs on his favorite theme, bullfighting. He drew directly onto the lithographic stone with black crayon.

In miniature painting he developed a completely new way of working. Perhaps inspired by miniatures he had seen in Paris, he painted on tiny pieces of ivory. He began by blackening the surface of a small piece of ivory and then dripping water onto it. The accidental shapes formed in this way provided him with ideas for painting, and he now added details with the point of his paintbrush, working the shapes into greater precision and here and there adding accents of color. In this way he painted a man delousing a dog (above), a man eating leeks, children reading, old people. Even Goya's ever-changing theme of the coquettish Spanish maja re-emerges (right). He himself estimated that he painted 40 of these ivory miniatures.

At the same time, he was teaching drawing to Leocadia's ten-year-old daughter and was also busy drawing for himself; his albums from this period contain over 200 drawings. In these carefully composed pages he expressed both the horrific and the amusing, what he had seen and what he had imagined. These expressive drawings are undoubtedly among the masterpieces of his graphic works.

A Man Delousing a Small Dog
1824–1825
Charcoal and watercolor on ivory
9 x 8.5 cm
Dresden, Galerie Neuer Meister, Kupferstichkabinett

This tiny image shows an everyday scene in a free and lively style. Goya's late miniatures demonstrate his enormous artistic mastery.

Majo and Maja
1824–1825
Charcoal and watercolor on ivory
9 x 8.5 cm
Stockholm, Nationalmuseum

On April 16, 1828, Francisco de Goya y Lucientes died in Bordeaux at the age of 82. In France at this time, the first copies of individual prints from the *Caprichos* series were already circulating. The young painter Eugène Delacroix mentioned Goya's name in the same breath as that of Michelangelo. He was the first of a long line of 19th- and 20th-century artists influenced by Goya's work, including Honoré Daumier, Edouard Manet, Pablo Picasso, and many others.

Today most of Goya's paintings are in the Prado in Madrid; his prints are to be found in many great museums throughout the world.

Old Man on a Swing

1824–1828
Black chalk on paper
19 x 15.1 cm
New York, Hispanic Society of America

The drawing comes from the same album as *Dancing Ghost* (right) and is one of the most famous prints from the late Goya; he also used this theme in an etching. With no firm footing and only the swinging rope in his hand, the old man swings laughingly through the air. His instability gives the old man a foolish pleasure instead of anxiety or discomfort. Goya seems to be contradicting clichés about the wisdom of old age. It is surely not by chance that his childish old people all look alike and could even be grotesque mutations of his own image.

Dancing Ghost

1824–1828
Black chalk on paper
18.9 x 13.9 cm
Madrid, Prado

The round-faced old man in the monk's robes is dancing to the rhythm of the castanets: he creates the effect of a merry ghost, a little mad but not frightening. Goya positioned the pale figure before a dark background, thus giving it a strong presence.

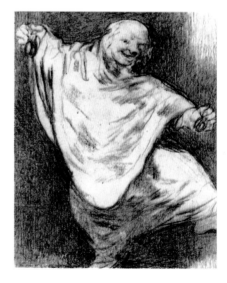

Glossary

Academy An official art school, at which not only technical skills but also the aesthetic concepts of a period were taught.

Aquatint (from Latin *aqua fortis*, "acid," and the Italian *tinta*, "color") A printing technique used to create finely granulated tonal areas as well as the sharp lines of standard etching processes. The plate is covered with a coat of resin on which a design is drawn with acid-resistant varnish. The plate is immersed in acid, which eats through the unvarnished resin to produce evenly pitted areas. These fine pits carry the ink for printing, producing areas of tone that can be carefully varied. The process is usually combined with linear etching.

Baroque (from the Portuguese *barocco*, "irregular") The period of European art between ca. 1600 and ca. 1750. Starting in Rome, the Baroque extended across the whole of Europe, taking on very different forms according to national, political, and religious differences. The main characteristics of Baroque include dramatic effects of light and space, dynamic compositions, and an emphasis on intense emotions.

Cabinet picture A small painting. Originally (in the 17th century), one small enough to be kept in a "cabinet of curiosities," where connoisseurs displayed their collections of art works and curiosities.

Capriccio plural **capricci** (Italian for "caprice") A landscape or architectural view that combines real and imaginary elements.

Cartoon (from the Italian *cartone*, "pasteboard card") A full-scale preparatory drawing for a painting, tapestry, or fresco. Cartoons for frescoes and paintings were usually drawings (as it was the design that was important); while those for tapestries were usually paintings, as it was necessary to reproduce the colors through weaving techniques.

Composition (from the Latin *compositio*, "placing together") The art of combining the elements of a picture into a satisfying visual whole. The elements include color and form, line, symmetry and asymmetry, movement, rhythm, etc.

Engraving A printing technique, invented in southwest Germany about 1440, in which a design is cut into a metal plate (usually copper) by means of a sharp instrument. When ink is wiped firmly across the plate it fills the fine incised lines and is then transferred to paper when the plate and the paper sheet are pressed together.

Etching A printing technique in which a design is cut into a printing plate by acid. The metal plate is covered in wax into which the design is drawn with a sharp needle. The plate is then immersed in acid, which eats into the plate where the wax has been scraped away. This creates the lines that will hold ink for printing. Etching developed in the early 16th century.

Fresco (from the Italian *fresco*, "fresh [plaster]") A technique of wall paintings in which color is applied to wet plaster. The color bonds chemically with the plaster as it dries and so forms a very durable image. Fresco designs have to be painted quickly and confidently, as errors cannot be corrected when the plaster has dried.

Genre painting (from the French *genre*, "type") Depictions of everyday life. Genre painting emerged as an independent form in the 16th century. Bruegel (ca. 1525–1569) developed genre painting in Holland, and Caravaggio (1571–1610) in Italy, but it was in Holland in the 17th century that it became an independent form with its own major achievements.

Graphics Any of the visual arts based on drawing or the use of line rather than color. Examples include drawing, engraving, woodcut, and etching.

Hatching In a drawing, printing, or painting, a series of close parallel lines that create the effect of shadow, and therefore contour and three-dimensionality. In *cross-hatching* the lines overlap.

History painting The genre of painting concerned with the depiction not only of historical events but also of mythological, biblical, religious, and literary scenes. Until the end of the 19th century history painting was considered the most important genre (it was thought morally elevating), followed by the portrait and then the "lower genres" of landscape, genre, and still-life.

Impasto Oil paint applied very thickly, with a brush or palette knife, creating a richly textured surface.

Lithography A printing technique in which a design is drawn directly onto a limestone (sometimes zinc) plate. A design is drawn on to the plate with a greasy crayon and the plate is then wetted. When an oil-based ink is then spread across the plate it adheres to the greasy design but is repelled by the wet surfaces. Paper can now be pressed onto the plate in order to make a print. The process was invented in 1797 by the German writer Aloys Senefelder (1771–1834).

Motif The central theme of a work of art or literature; a recurrent thematic element or image in a work.

Neoclassicism A style in art, architecture, and design that flourished ca. 1750–1840. It was based on the revival of the styles and subjects of classical antiquity. Intellectually and politically, Neoclassicism was closely linked to the Enlightenment rejection of the aristocratic frivolity of Rococo, the style of the Ancien Régime. Among Neoclassicism's leading figures were the French painter Jacques-

Louis David (1744–1825) and the German painter Anton Raffael Mengs (1728–1779).

Oil painting A painting technique in which color pigments are bound with a natural oil, such as linseed. Oil paints are smooth and creamy and can be worked together easily, producing a wide range of subtle tones and colors. Oil paint can be applied in thin, transparent layers or very thickly. Oil painting developed in the 15th century and has since been the predominant medium in European painting.

Rococo A style of design, painting, and architecture dominating the 18th century. Developing in the Paris townhouses of the French aristocracy at the turn of the 18th century, Rococo was elegant and ornately decorative, its mood light-hearted and witty. Louis XV furniture, richly decorated with organic forms, is a typical product. Leading exponents of the Rococo style included the French painters Antoine Watteau (1684–1721) and and Jean-Honoré Fragonard (1732–1806).

Sepia A dark brown pigment made from the ink sacs of such marine creatures as the cuttlefish. This has been used as ink and watercolor since the middle of the 18th century.

Silkscreen printing A printing technique in which prints are made using a screen consisting of a piece of very fine material stretched on a frame. When a design is drawn on the screen, the areas which are to appear blank on the print are blocked off with a kind of glue, in effect creating a stencil. Then, using a scraper, color is forced through the screen onto the paper below, reproducing the form made by the stencil. Usually several printings are required, one for each color.

Study A trial drawing for a painting or sculpture. Studies can be executed in a wide variety of formats, their degree of completeness ranging from a fleeting sketch to a detailed drawing.

Surrealism A literary and artistic movement launched in France in 1924 by the French poet André Breton (1896–1966). Rejecting conscious control as inhibiting, Surrealist artists attempted to draw on unconscious forces of the psyche. They created strange, disturbing, fantastical images, often by bringing together everyday objects in bizarre combinations.

Tapestry A hand-woven wall hanging, usually made from silk or wool. Artists were often employed to create designs that weavers would turn into tapestries. The Flemish tapestry makers of the 15th–18th centuries were particularly highly regarded. Their art spread throughout Europe, the residences of the aristocracy and affluent citizens being decorated with increasingly refined tapestries.

Index

Chronology Images

Acknowledgments

The publisher thanks the museums, archives and photographers for their permission to use reproductions and their kind support in the completion of this book.

All other reproductions are from the institutions named in the captions or from the publisher's archives. The publisher has made every effort to obtain the copyright for the reproductions of all the works of art involved. Nevertheless, if further legal rights exist in this respect, those concerned are requested to contact the publisher.

© Archiv für Kunst und Geschichte, Berlin: 2, 7 a r, 17 a l, 20 r, 22 a, 23 c, 25 a l, 37 a l, 45 a l, 52 b r, 55 a l, 63 b; (photos Erich Lessing) 65 a l, 77 a l, 78, 85 a l, 87 a, 89 b.

© Archivo Fotografico Electa, Milan: 10 a, 12 l.

© Artephot/Oronoz, Paris: 4 a l, 5 a l, 6, 36.

© Artothek, Peissenberg: 60 l; (photos Joseph S. Martin) cover, 5 b r/b l, 17 a r, 21, 62 a, 63 a, 76, 84; (photo Hans Hinz) 27 r.

© Biblioteca Nacional Madrid: 37 b, 89 a r.

© Bildarchiv Preussischer Kulturbesitz, Berlin 1999: (photos D. Katz) 42 a r, 77 b.

© The Bridgeman Art Library, London: 4 a r/b l, 5 a r, 24, 28 a, 29, 31 b, 33 a r/a l/b, 40 b, 44, 46, 48 a /b, 49 r/l, 51, 52 a /b l, 53, 54, 56, 57 a, 59, 65 b, 67 l, 68, 70 l, 71, 72, 75 a r/a l, 80, 81 b, 82 l/b, 83 b, back cover.

© Succession Picasso/VG Bild-Kunst, Bonn 1999: Pablo Picasso
© VG Bild-Kunst, Bonn 1999: Wolf Vostell

© 1999 Könemann Verlagsgesellschaft mbH
Bonner Straße 126, D-50968 Cologne

Editor: Peter Delius

Concept: Ludwig Könemann
Art director: Peter Feierabend
Cover design: Claudio Martinez
Editing of the original edition and layout: Barbara Delius
Picture research: Jens Tewes
Production: Mark Voges
Lithography: TIFF Digital Repro GmbH, Dortmund

Original title: Francisco de Goya

© 1999 Könemann Verlagsgesellschaft mbH
Bonner Straße 126, D-50968 Cologne

Translation from German: Phil Greenhead in association with Goodfellow & Egan, Cambridge
Editing: Chris Murray in association with Goodfellow & Egan, Cambridge
Typesetting: Goodfellow & Egan, Cambridge
Project management: Jackie Dobbyne for Goodfellow & Egan Publishing Management, Cambridge, UK
Project coordination: Nadja Bremse
Production: Ursula Schümer

Printing and binding: Sing Cheong Printing Co., Ltd., Hong Kong

Printed in Hong Kong, China
ISBN 3-8290-2930-6

10 9 8 7 6 5 4 3 2 1

Cover:
The Parasol
1777
Oil on canvas
104 x 152 cm
Madrid, Prado

Page 2:
Self-Portrait
1815
Madrid, Real Academia

Back Cover:
Self-Portrait
Capricho No. 1 (detail)
1797–1798
Etching and aquatint
21.9 x 15.2